W9-BED-290

1 9 6 7 : A T T H E C R O S S R O A D S

J A N E T K A R D O N

M A R C H 1 3 – A P R I L 2 6 , 1 9 8 7

I N S T I T U T E O F C O N T E M P O R A R Y A R T

U N I V E R S I T Y O F P E N N S Y L V A N I A

This exhibition and publication have been made possible in part by grants from The Dietrich Foundation; Edna and Stanley C. Tuttleman; the National Endowment for the Arts, Washington, D.C., a federal agency; the Pennsylvania Council on the Arts; and the City of Philadelphia.

Copyright © 1987
Institute of Contemporary Art
University of Pennsylvania

All rights reserved.
ISBN 0-88454-042-1
Library of Congress Catalogue Card
No. 87-80322

"1967/87" copyright © 1987 by Hal Foster.

"1967: Out of Minimal Sculpture"
copyright © 1987 by Irving Sandler.

Design: Scorsone/Drueding
Typography: Duke & Company
Printing: Revere Press

Artists in the Exhibition

CARL ANDRE	DONALD JUDD	CLAES OLDENBURG
MEL BOCHNER	ON KAWARA	JULES OLITSKI
ALEXANDER CALDER	ELLSWORTH KELLY	DENNIS OPPENHEIM
CHRISTO	JOSEPH KOSUTH	ROBERT RAUSCHENBERG
WALTER DE MARIA	ALFRED LESLIE	ED RUSCHA
DAN GRAHAM	BARRY LE VA	LUCAS SAMARAS
RED GROOMS	SOL LEWITT	RICHARD SERRA
MICHAEL HEIZER	ROY LICHTENSTEIN	TONY SMITH
AL HELD	AGNES MARTIN	ROBERT SMITHSON
EVA HESSE	ROBERT MORRIS	FRANK STELLA
ROBERT INDIANA	BRUCE NAUMAN	RICHARD TUTTLE
RAY JOHNSON	BARNETT NEWMAN	ANDY WARHOL

Acknowledgments

The exhibition "1967: At the Crossroads" focuses on a single year in a pivotal decade of American art, a moment when rising and waning issues intersected and competing aesthetics permeated a crowded cultural climate. For this reason, our selection has been as representative as possible, and includes color-field painting, large-scale public sculpture, minimal art, postminimalism, earthworks, conceptual pieces, pop art, and realism. Since all the works were begun, completed, or first exhibited publicly in 1967, I am especially grateful to the many generous individuals, galleries, and museums that helped to make this show possible, as well as to those artists who agreed to lend their works.

Four writers—Hal Foster, Lucy Lippard, Barbara Rose, and Irving Sandler—have contributed essays to this catalogue. The Rose and Sandler interviews in their *Art in America* article, "Sensibility of the Sixties," were an important benchmark of the year. Rose also wrote other key pieces; Sandler, the scene's most indefatigable observer, was a constant witness. Lippard's book *Six Years: The demateriali-zation of the art object . . .* is the best short-term history of the move from minimalism to conceptualism; she was also closely associated with the evolution of the new art. To their essays has been added one by Foster, a cogent younger critic who emerged in the eighties. The insights of all four writers have significantly enhanced this publication.

Organizing an exhibition and producing a catalogue are collaborative endeavors, and the ICA staff has conscientiously devoted its attention to the numerous aspects involved. Judith Tannenbaum, ICA's assistant director/curator, has expertly attended to the large demands of the project. Jane Carroll, curatorial assistant, carefully compiled the bibliography and served as registrar; Victoria Glickstein, curatorial assistant, dependably handled many details. Tom Bolze, assistant to the director, assembled the materials for the catalogue with diligence and precision. I am also grateful to Carole Clarke, chief development officer, Rosemarie Fabien, public information officer, and Fran Kellenbenz, business administrator, for their special skills that have enhanced our efforts. ICA's excellent installation crew, ably directed by John Taylor, included William Baumann, Randall Dalton, Max Mason, Ron Rozewski, Greg Tobias, and Jack Toland.

The design for the exhibition catalogue, which so appropriately reflects the theme, was conceived by Joe Scorsone and Alice Drueding. Richard Weisman, Kathleen Friel, and Gerald Zeigerman, of Duke & Company, provided expert editing and typography.

In reconstructing the year's important events and in locating

specific works, I have relied upon the resources and collective memory of many colleagues. I am especially grateful to Douglas Baxter, Paula Cooper Gallery; Richard Bellamy; Anne Carley and Virginia Dwan; Thomas Neil Crater; Martin Friedman, Walker Art Center; Joseph Helman, Blum Helman Gallery; Antonio Homen, Sonnabend Gallery; Frank Hodsoll, chairman, Keith Stevens, and Jeannette Christian from the National Endowment for the Arts; Nathan Kolodner, Andre Emmerich Gallery; Jill Weinberg and Xavier Fourcade, Xavier Fourcade Gallery; Elizabeth Turner; Patty Brundage, MaryJo Marks, and Leo Castelli, Leo Castelli Gallery; Louise Deutschman and Carroll Janis, Sidney Janis Gallery; Andrea Miller-Keller, Wadsworth Atheneum; Jan van der Marck, Detroit Institute of Arts; Walter Hopps, Menil Foundation; Annalee Newman; Amy Plumb; Phyllis Rosenzweig, Hirshhorn Museum and Sculpture Garden; William Rubin, director, department of painting and sculpture, and Cora Rosevear, The Museum of Modern Art; Arnold Glimcher and Susan Ryan, The Pace Gallery; Lowery Sims, Metropolitan Museum of Art; Chuck SanClementi, Terese Schmittroth, Brook Sigal, and Holly Solomon, Holly Solomon Gallery; Tom Sokolowski, Grey Art Gallery, New York University; Elyse Goldberg, John Weber Gallery; and Joshua Mack and Angela Westwater, Sperone Westwater Gallery. My discussions with many of the artists in the exhibition were invaluable.

The funding of the exhibition and catalogue has been made possible by generous grants from the National Endowment for the Arts, the Pennsylvania Council on the Arts, and the City of Philadelphia. The Dietrich Foundation and Edna and Stanley C. Tuttleman have my warmest, heartfelt gratitude for their significant contributions. All of ICA's advisory board has lent its encouragement, and I particularly wish to thank Daniel W. Dietrich II, exhibition committee chairman; Harvey S. Shipley Miller, chairman; and Mrs. Berton E. Korman, president, who led the ICA at the inception of the exhibition; and Susan D. Ravenscroft, current chairman, who so ably continued their leadership to its fruition.

My greatest appreciation is extended to the artists. Their imperatives defined 1967.

Janet Kardon
Director
Institute of Contemporary Art

Lenders to the Exhibition

Mrs. Edwin Bergman, Chicago
Benjamin Buchloh, New York
Jeanne-Claude Christo, New York
Paula Cooper Gallery, New York
Mr. and Mrs. Daniel W. Dietrich II, Chester Springs, Pennsylvania
Virginia Dwan, New York
Heiner Friedrich, New York
Mr. and Mrs. Victor W. Ganz, New York
Dan Graham, New York
Michael Heizer, New York
Al Held, New York
Betsey Johnson, New York
On Kawara, New York
Mr. and Mrs. M. S. Keeler II, Grand Rapids
Ellsworth Kelly, Spencertown, New York
Kasper Koenig, Cologne
Alfred Leslie, New York
Sol LeWitt Collection, Wadsworth Atheneum, Hartford
Nicholas Logsdail, Lisson Gallery, London
Lysiane Luong, New York
Menil Foundation, Houston
Barbara and Peter Moore, New York
F. and D. Morellet, Cholet, France
The Museum of Modern Art, New York
National Endowment for the Arts, Washington, D.C.
Jules Olitski, Brooklyn, New York
Dennis Oppenheim, New York
The Pace Gallery, New York
PaineWebber Group Inc., New York
Robert Rauschenberg, New York
Estate of Tony Smith
Estate of Robert Smithson
Holly Solomon Gallery, New York
Sonnabend Gallery, New York
Ileana and Michael Sonnabend, New York
Robert L. B. Tobin, San Antonio
Richard Tuttle, New York
University of Pennsylvania, Philadelphia
Jan and Ingeborg van der Marck, Detroit
The Whitney Museum of American Art, New York
Williams College Museum of Art, Williamstown, Massachusetts
Private Collection

Contents

1967:
At the Crossroads

Janet Kardon

Time in art usually is read as it is in our lives—serially, one year after another, tracking that elusive entity, change. When did things change? we ask ourselves. How do we recognize that a thing is no longer itself but something else? We attempt to explain the difference by establishing cause and effect—our rational view of events. From this we construct history, or, perhaps more accurately, "history"— something that fits the data until a more convincing (though not necessarily more accurate) view comes along. History and theories of history bedevil our efforts to locate and explain change. Occasionally, we are provoked to cut the Gordian knot—to interrupt the smooth continuities bearing us across decades and periods—and cross-section the past. As the parameters for an exhibition, "1967: At the Crossroads" isolates a single year in American art, and affords us the opportunity to reexamine an extraordinary decade through one of its key years. The decade was one of exploration, with each new advancement marked by clearly defined borders that required their own language and attracted their own adherents.

The sixties are now distant enough to be sighted in historical perspective. In its way, that unsettling decade was as revolutionary as the twenties. Its social and political restlessness, and utopianism; its liaison between rock music and social change, and devastation of cities by race riots; its revisions of the status of women and minorities; the emergence of the drug culture and counterculture and the upheaval of the Vietnam War all kept us off-balance—and the effects of those years have hardly settled in the minds of many of us who lived through them. Hair was long, skirts were short, and we learned to read the politics of both. We had war and assassination served to us on television with our dinner. At its end, the decade gave us the moon.

A rapid succession of events (no longer could they be called movements) spun the wheel of artistic fashion. New ideas, new art flourished in the spotlight. For the first time, commerce, fashion, and the cutting edge were superimposed in ways that provoked the extreme responses of hip acceptance or puritan distaste. Public relations became intrinsic to the artistic enterprise. For the fortunate, rewards were high, permanently altering the expectations of the young artist. Did the new art anticipate, reflect, or criticize the social context? To what degree was art co-opted by the culture? To what degree was the art of the sixties betrayed by its own self-indulgence or did it constitute a serious criticism to the culture that brought it into being? What were the main issues of the period? And where might we locate ourselves in the decade to best recover the past and open the way for intelligent revisions?

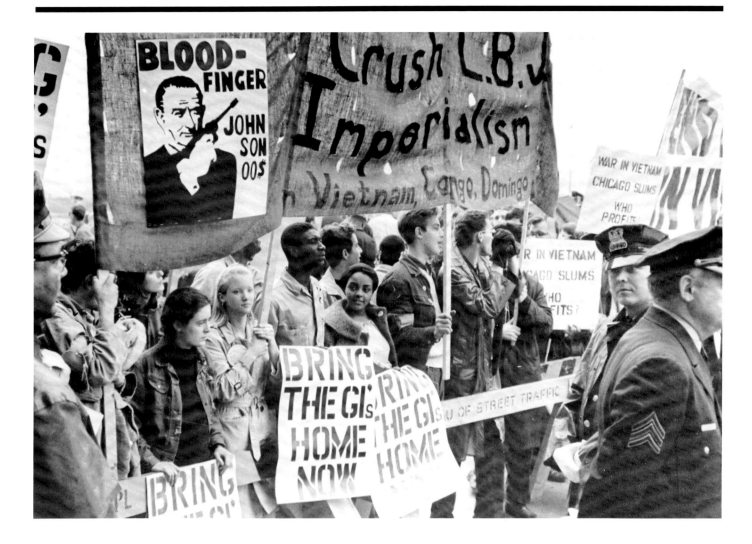

Each year affords different opportunities. The choice becomes the horizon against which the decade at large is perceived. Do we take 1962, the year of the "New Realist" exhibition, at the Sidney Janis Gallery, which confirmed the arrival of pop art? Or 1963, when color-field received its charter from Clement Greenberg in "Three New American Painters: Lewis, Noland, Olitski," at the Norman Mackenzie Art Gallery, in Saskatchewan? A brief fibrillation of color called optical art was celebrated and buried by the Museum of Modern Art in its 1965 exhibition "The Responsive Eye." By the middle of the decade,

ROY LEWIS, *"Special Agent LBJ," bring home the boys,* Chicago, 1967, silver print, 11 x 14.

kinetic art had clanked its way to silence. The Jewish Museum legitimized early- or midcareer retrospectives with its Robert Rauschenberg and Jasper Johns exhibitions, in 1963 and 1964, respectively. In 1966, collaborative events, such as art, dance, technology, and performance, were featured in "Nine Evenings," at the New York Armory, and visual artists, such as Robert Rauschenberg, crossed over into theatrical and scientific territory. Minimalism was codified in 1966, when the Jewish Museum's "Primary Structures" exhibition focused upon sculpture, and "Systemic Painting" was presented at the Guggenheim Museum. By the end of the decade, photorealist works appeared that New York resolutely refused to take seriously. A key exhibition of 1969 was "Anti-Illusion: Procedures/Materials," at the Whitney Museum of American Art.

Why choose a single year? What exactly can a cross section do for us? It is not so much to identify the diameters of particular strands —that is accomplished easily enough; what is more important about a cross section is that its contiguities and juxtapositions are far more complex and, hopefully, more provocative than any comparative examination of competing aesthetics at different stages of their individual creative cycles. The moments that contain the penumbra from which ideas emerge—and the new ground that these ideas open— prove the most compelling. Color-field, pop, kinetic, and optical art all seem to follow, wherever we make the cut, a predictable and steady arc. Their life cycle, if we use the biological metaphor rejected by early minimalism, is implicit in their premises, and their premises are declared at once.

Minimalism, however, is another story, although few wanted to hear it in the late seventies and early eighties. Any reconstruction of the sixties and seventies must find in minimalism's ideas and achievements a major impetus for the art that followed. Minimalism begat that diverse cluster of genres that inseminated the imaginations of a few generations (a generation being a brief five years): earthworks, conceptualism in all its guises, biographical art, photodocumentation, installations, and performance art, which it revivified. The exhibition revolves on the minimal-conceptual axis that generated objects intractable to easy marketing, objects that suffered from an economy in which validation is given, for the most part, by collector, museum, and auction house. As tastes change in the eighties, these somewhat pariah genres are being examined again.

The key year may be 1967, when second-generation minimalism was in transit to conceptualism. But how do we study the record? Rather, what record do we study? Exhibition history implicitly reports

on curatorial insight, the capacity to recognize the new or contribute to its definition. Two decades later, we are in the process of distinguishing between passing fashion and that which endures. This can be a difficult task in considering the sixties, a time when fashion and invention, running wild and tending to warp our perceptions, led to the charge that the curator, once the scholarly and detached witness, had become polemical at best and fashionably engagé at worst.

The decade's leading curators included Jan van der Marck, director, Museum of Contemporary Art, Chicago; Maurice Tuchman, curator, Los Angeles County Museum of Art; Kynaston McShine and Alan R. Solomon, curator and director, respectively, the Jewish Museum; James Monte and Marcia Tucker, curators, Whitney Museum of American Art; Lucy Lippard, the free-lance critic who curated "Eccentric Abstraction," in 1966; and the woman Harold Rosenberg called "the best curator of the sixties," Elayne Varian, who was responsible for a series of exemplary exhibitions at the Finch College Museum of Art. In addition, one cannot overlook several pioneering New York galleries and their directors who were often the first to showcase new work or current issues: Galeria Bonino, Bykert Gallery (under Klaus Kertess), Leo Castelli, Virginia Dwan, Marilyn Fischbach, Jill Kornblee, Howard Wise, Park Place (under Paula Cooper), and Sidney Janis.

The curatorial record, though, is only one factor, and other components—of what many are pleased to call "the scene"—could be examined and evaluated. Art journals, the semiofficial records of any year (with some adjustments allowed for editorial policies), make for provocative reading. These publications present a matrix teeming with judgments, prejudices, and juxtapositions that are the raw substance of history. In the sixties, *Artforum,* under the leadership of Philip Leider, argued the case for the new. *Arts Magazine,* with Hilton Kramer as editor from 1958 to 1961, maintained a rigorous testing posture; later in the decade, it published the writings of a few key artists. *Artnews,* under Tom Hess, moved cautiously into the decade after a heady period of being the prime supporter of abstract expressionism and its progeny. *Art in America,* under Jean Lipman, and *Art International,* under James Fitzsimmons, presented important essays, some by artists, which are durable attempts to decipher the sixties.

One of the missing histories of the postwar era is a thorough study of the changed role of the collector in postwar American art. The forties and fifties picture is obvious—the pioneering and generally unrecognized artist was collected by the pioneering and generally unknown collector. In the sixties, a new collector emerged—one who, wishing to share the risks and spotlight with the artist, became a sig-

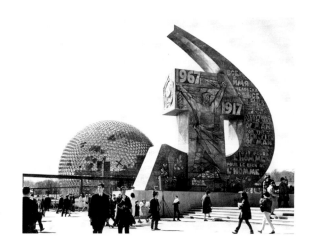

Soviet and U.S. pavilions at Expo '67, Montreal.

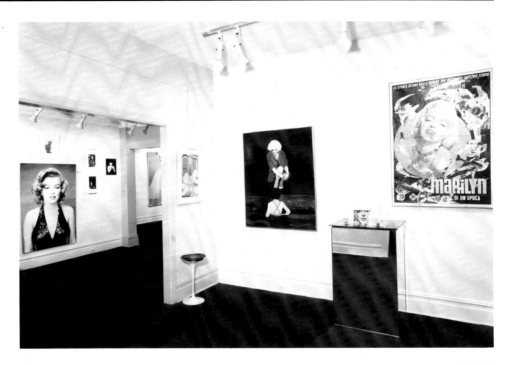

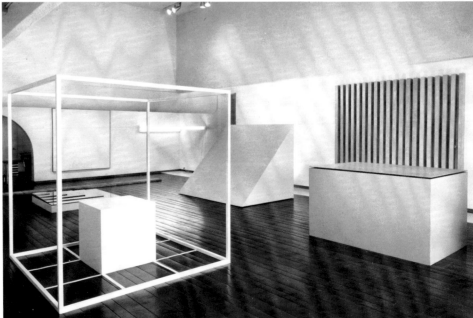

Top: "Homage to Marilyn Monroe,"
installation view, Sidney Janis Gallery,
New York, 6–30 December. Photograph
courtesy Sidney Janis Gallery, New York.
Bottom: "10," installation view, Dwan
Gallery, Los Angeles, 2–29 May.

12

nificant force in establishing reputations and influencing the market. The new collector of the sixties, like the curator, tended to believe that he or she was a sympathetic collaborator partaking loosely in the artists' ideas and development, and who, in some cases, even felt entitled to share that artist's public reputation. In the sixties, the collector's attention shifted to new and untested work and the patronage of the young artist. This, replicated with redoubled energy in the eighties, becomes a common form of gambling on the future. The idea of set value, proven talent, and sound connoisseurship has been replaced by relative value, untested talent, and fashionable connoisseurship.

The exhibition "1967: At the Crossroads" revolves on the minimal-conceptual axis. The virtue of a cross section is its restoration in one exhibition of artworks and ideas contiguous in time although frequently antagonistic in aesthetic. Color-field and minimalism had little use for each other, and their critics enjoyed a mutual hostility. Pop art shared certain attitudes and interests with minimalism, but, as a movement, it had virtually disappeared by 1967, having been reduced to its major practitioners or survivors—the fate of every new wave when it withdraws. History, as we now conceive it, has little room for outsiders—or figures pursuing idiosyncratic visions—who are not swept along on that all-too-familiar wave. Ironically, what was perceived at the time to be disparate, may look more *or* less homogeneous in this exhibition.

All the works included in this catalogue were begun, completed, or first exhibited in 1967. As the difficulties in obtaining works from a single year have proven formidable, the catalogue takes on an added importance: By reproducing several works that were not made available or were logistically impossible to display, it offers a more comprehensive portrait of the period. The presentation of both the exhibition and the catalogue gives one the opportunity to rethink a year at a propitious moment when sixties artworks are considered to be, for a certain group of younger artists, very fertile fields.

Janet Kardon
Director
Institute of Contemporary Art

1967/1987

Hal Foster

1967–68 may well be our 1848, a revolutionary moment that remains a historical crux, one that defines the political field (mostly in terms of reaction) for years to come. Just as the hopes and fears of 1848–51 remained an idée fixe for the generation of Flaubert, so 1967–68 lives on as an apocalyptic moment for some, as a traumatic scene for others. For it was in the sixties, of course, that many forms of American culture were transvalued—not only in the counterculture of the black, student, and women's movements but also in the rare realms of art. After all, the two most important art practices of the early decade, minimalism and pop, worked to reposition the work of high art: in the case of minimalism, toward the objectivity of industrial objects; in the case of pop, toward the seriality of mass-cultural images. It is this avant-gardist ambition (with its attendant device, the ready-made, adapted to serial production) that unites minimalism and pop; and it is this ambition, in part, that has provoked conservative condemnation both then and now.

These attacks on minimalism and pop differ. For critics in the sixties (I have in mind Clement Greenberg and Michael Fried, in particular), such art was arbitrary, even nihilistic—a grave threat to the formal quality (the institutional integrity?) of modernist painting and sculpture. As we will see, this defense of the "quality" of formal art against the mere "interest" of minimalist and pop art led to a perceptive critique. This is not the case with most contemporary attacks, which, in the service of a conservative humanist art, tend to dismiss it in a very banal way as cold or inhuman.

The two attacks, nevertheless, do share a symptomatic vehemence, a vehemence that goes beyond offended art preferences. (This traumatic response is most evident in neoconservative trashings of sixties culture in general [cf. Hilton Kramer, Daniel Bell], trashings incommensurate with the acculturated status of minimalism and pop today—for are they not treated now as the master museum styles of sixties art?) For art critics like Greenberg and Fried, minimalism and pop are traumatic because they break with the late-modernist paradigm of art; for neoconservatives like Kramer and Bell, they are traumatic because this break is related to other ruptures of the sixties. For this reason, minimalism and pop are often attacked; for this reason, too, these attacks must be read symptomatically—as resisted recognitions of the status of minimalism and pop as a *crux* in (post)modernist culture. The burden of this short essay is to describe the crucial status of minimalism, in particular; I will begin with its two fundamental texts: Donald Judd's "Specific Objects" (1965) and Michael Fried's "Art and Objecthood" (1967).[1]

The first two claims of "Specific Objects"—minimalism is neither "painting nor sculpture," and "linear history has unraveled somewhat"—contest the two most important tenets of Greenbergian formalism: Art exists as such only within the given mediums, and its forms evolve in a historicist way. And yet, this contestation developed as a close reading. For example, what is regarded by Greenberg as a definitional *essence* of painting—its form is determined by its edge—is taken by Judd as a conventional *limit,* literally a frame to exceed. Judd attempts to do this, of course, through the creation of "specific objects" (which, he makes clear, are discursively closer to late-modernist painting than to late-modernist sculpture, "anthropomorphic" as this often still is). In short, Judd reads the Greenberg call for an objective painting so literally as to exceed painting altogether in the production of objects. For what, he asks, can be more *objective* than an object in real space? Moved to fulfill the late-modernist program, Judd breaks with it, as is clear from his list of specific-object prototypes: Marcel Duchamp's readymades, Jasper Johns's cast objects, Robert Rauschenberg's combines, John Chamberlain's scrapmetal sculptures, Frank Stella's shaped canvases—hardly a list of Greenberg favorites.

As Judd implies, all these avant-gardists assume that "painting

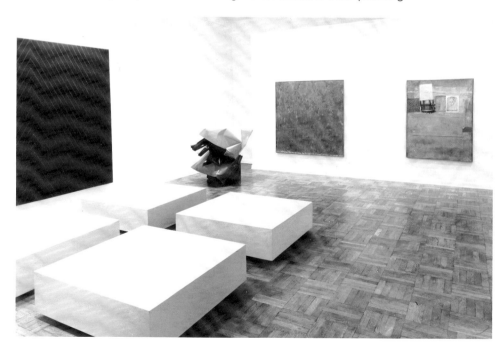

"Ten Years," installation view, Leo Castelli Gallery, New York, 4–26 February.

and sculpture have become set forms," i.e., forms too rigid to be inflected further. "The use of three dimensions," he claims (note that he, no more than Greenberg, calls minimalism "sculpture"), "isn't the use of a given form," isn't conventional in this sense. Indeed, in the realm of objects, Judd suggests, *any* form, material, or process can be used. This expansion of art opens up criticism, too, as he is led by his own logic to this infamous avant-gardist claim: "A work of art needs only to be interesting." Here, consciously or not, "interest" is posed against the great Greenbergian shibboleth "quality": whereas quality is assessed by reference to the works of the great moderns and the standards of the old masters, interest is to be judged according to the self-consciousness of a given artwork regarding its own conventionality. Quality is a conservative criterion, a blessing bestowed upon aesthetic refinement; interest is an avant-gardist intent, often anti-aesthetic in effect.

In "Specific Objects," the late-modernist mandate that art pursue the objective is completed, only to be exceeded, as Judd and company come out the other side of painting into the realm of objects. This transgression opens up a new situation for art, and it is precisely this situational aesthetic, so important to art after minimalism (conceptual art, performance, site-specific art), that Michael Fried, in "Art and Objecthood," is pledged to forestall.

Even more than the Judd text, this famous essay comprehends minimalism fully in its threat to (formalist) modernism. First, Fried details the crime of minimalism: its attempt to displace modernist art by means of a literal reading, which confuses the transcendental "presentness" of art with the mere objecthood of things. (According to Fried, the essential difference between minimalist and late-modernist art is that the first seeks "to discover and project objecthood as such," whereas the second aspires "to defeat or suspend" objecthood, to transcend the *literal* in order to achieve the *present*.) Next, Fried argues that minimalist literalism is "antithetical to art." Specifically, he claims that the "presence" of the minimalist work (not to be confused with the "presentness" of the modernist work) sets up a *situation* extrinsic to visual art. In effect, Fried claims, the minimalist object acts as a surrogate person. The point here is not simply to show up minimalism as anthropomorphic (as minimalism finds sculpture in general) but, rather, to present it as "incurably theatrical," for, according to the crucial hypothesis of the essay, "Theater is now the negation of art."

To back up this hypothesis, Fried makes a strange detour—a gloss on an anecdote told by sculptor Tony Smith about a ride on the unfinished New Jersey Turnpike one night in the early fifties. For Smith,

the protominimalist, this experience was somehow aesthetic but not quite art:

> The experience on the road was something mapped out but not socially recognized. I thought to myself, it ought to be clear that's the end of art. Most painting looks pretty pictorial after that. There is no way you can frame it, you just have to experience it.

What was revealed to Smith, Fried writes, was "the conventional nature of art. . . . And this Smith seems to have understood not as laying bare the essence of art, but as announcing its end."

Here, I believe, is the crux not only of the Fried case against minimalism but also of the minimalist break with modernist art. In the Smith epiphany about the conventionality of art, the heretical stake of minimalism and its avant-gardist successors is foretold: not to discover the essence of art à la Greenberg but to transgress its institutional limits ("there is no way you can frame it"), to reconnect it with life ("you just have to experience it"), precisely to announce its end. For Fried, as for Greenberg, such avant-gardism is infantile: Minimalism, they say, only obtains a frameless object "as it *happens,* as it merely *is.*" This is why Fried calls minimalism "theatrical": it involves mundane time and so threatens the very order of the arts (that is, the temporal arts versus the spatial arts); and this, finally, is why "theater is now the negation of art" and why minimalism must be condemned.

We are left with this alternative: either the hellish "endlessness" of minimalist "theater" or the sublime "instantaneousness" of the modernist work, "which at every moment . . . is wholly manifest." More than a historical paradigm, more even than an aesthetic essence, this presentness becomes, for Fried at the end of "Art and Objecthood," a spiritual imperative: "Presentness is grace." It is appropriate that at its conclusion the theological motives of this essay be revealed. (Indeed, with its condemnation of theater and its insistence on direct grace, it is distinctly puritanical—all the more so given that it ends with a call to faith.) Against avant-gardist atheism, we are asked to believe in quality, conviction, grace. In short, beyond respect for the old decorum of the arts, Fried demands Devotion to Art. He sees (rightly, I think) that minimalism may not only disrupt the formal order of the arts but also corrode our belief in them. For some, like Fried, who resist the crux of minimalism, this is its great threat; for others, who begin from its break, this is its great promise.

In sum, minimalism develops out of late modernism only to "corrupt" it, literally to break it apart (*corrumpere* = to break), contaminated as minimalism already is by the temporality of theater. Here, we can

take "theater" to mean more than a concern with time alien to visual art; it is also, as "the negation of art," a code word for avant-gardism. We arrive, then, at this equation: Minimalism breaks with late modernism, in part, via a recovery of the avant-garde, specifically its disruption of the formal categories of institutional art (remember Judd's list: Duchamp, Rauschenberg . . .). In this equation, minimalism emerges as a dialectical moment of "a new limit and a new freedom" for art, in which, for example, sculpture is reduced one moment to the status of a thing "between an object and a monument"[2] and expanded the next moment to an experience of sites "mapped out" but "not socially recognized" ("turnpikes, airstrips, drill grounds"—the very "expanded field" thought preposterous by Fried but soon explored by Robert Smithson and others). Minimalism appears as a historical crux, in which the formalist autonomy of modernist art is at once achieved and broken up, in which the ideal of pure art becomes the reality of just another specific object among serial others, "one thing after another."[3]

This last point leads to the other side of the minimalist rupture, for if minimalism breaks with late-modernist art, by the same token it must allow for the postmodernist art to come. And, indeed, even as minimalism consummates the late-modernist concern with the mate-

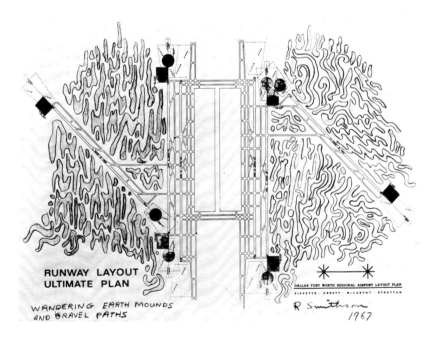

Robert Smithson, *Wandering Earth Mounds and Gravel Paths*, drawing, 10¾ x 14.

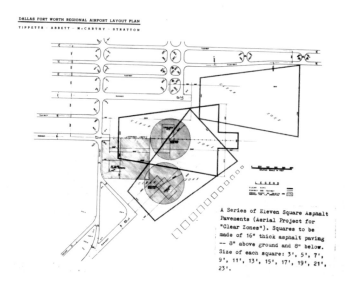

Robert Smithson, *A Series of 11 Square Asphalt Pavements* (aerial project for *"Clear Zones"*), 1966, photostat composite.

rial and present aspects of art, it also initiates the postmodernist critique of its institutional and discursive conditions. This reading of critical art after minimalism is more genealogical than historical: It is concerned not with stylistic influences but with critical displacements. (For instance, an artist like Louise Lawler has no manifest connection to an artist like Donald Judd, yet they are linked in a genealogy of art critical of its received institutions.) This reading has developed over the past ten years, but there are a few moments in its construction that I want to rehearse here. Significantly, in each moment, minimalism is treated as a crux—either as a break with the modernist aesthetic or as a reprise of strategies of the readymade—but not, as is necessary, as *both*.

Both Douglas Crimp and Craig Owens take as a point of departure the aesthetic order mapped out in "Art and Objecthood." For Crimp, it is precisely the theatrical, repressed in late modernism, that returns in performance and video art of the seventies (to be later re-contained in the "pictures" of Cindy Sherman, Robert Longo, Troy Brauntuch, and Jack Goldstein); for Owens, it is the verbal that erupts to disperse the old order of the image—textual art (e.g., the radical

19

modes of Smithson), allegorical art (e.g., the rhetorical collisions of Laurie Anderson).[4] And yet, if the first scenario overlooks the institution-critical art that develops out of minimalism, the second neglects the historical forces behind this textual fragmentation of art. (Indeed, neither scheme fully analyzes the historical conditions of these artistic transformations.)

Now, as an analysis of perception, minimalism is also an analysis of the conditions of perception. Logically, this leads to a critique of the spaces of art (e.g., Michael Asher), of its exhibitional conventions (e.g., Daniel Buren), of its commodity status (e.g., Hans Haacke); in short, a passage from perceptual critique to institutional critique. For Benjamin Buchloh, this history is essentially a genealogy of the presentational strategies, at once constructive and allegorical, of the readymade.[5] And yet, this narrative also leaves out a crucial element: the concern with the constitution (sexual, linguistic, etc.) of the subject—artist and viewer. It is left out as well in the art, for even as minimalism turned from the object orientation of formalist art to the subject orientation of postformalist art, it tended to treat the perceiver as historically innocent, sexually indifferent—as did the institution-critical art that developed out of minimalism. For later (especially feminist) critical art, this subject orientation is of the utmost importance, and it has led these disparate artists (Barbara Kruger, Mary Kelly, Martha Rosler, Louise Lawler, Silvia Kolbowski, among others) to discourses adjacent to the art world—most obviously, mass-cultural images and/ or psychoanalytical representations of women. It is largely in the ramifications of this dialectical argument (within and without the art world) that contemporary critical art is still engaged, and it is here, too, that the genealogy of critical art in the eighties will be traced.

There is, however, another reading of minimalism and pop that has emerged in very recent art: I have in mind the neominimal paintings of artists such as Peter Halley and the neopop readymades of artists such as Jeff Koons. To grasp the stake of this art, we must return to the relationship between minimalism and pop in the sixties. Basically, minimalism and pop were different responses to the same contradiction—that between high art and mass commodity. In order to articulate this old contradiction, they retooled the old device of the readymade to suit late-capitalist conditions (e.g., serial objects and images). Now, neominimal painting and neopop sculpture use similar devices for similar reasons, but they tend to collapse rather than articulate the contradiction between art and commodity; so, too, they tend to elide rather than extend the critical strategies of art since minimalism and pop. In this way, the transgressive procedures of mini-

malism and pop often seem emptied out: In neominimal painting, the minimalist object is returned to the domain of painting, its old antagonist; in neopop sculpture, the pop readymade is made to celebrate the commodity, its old object of parody.[6] The result is a simulation of minimalism and pop that may well invert the significance of both. Nevertheless, it is again testimony to the crucial status of both minimalism and pop that two of the most touted forms of art today—work that continues their institutional critique and work that simulates their styles—still dispute their legacy.

Notes

1. The Judd essay can be found in *Donald Judd: Complete Writings 1959–1975* (Halifax and New York: The Press of the Nova Scotia College of Art and Design and New York University Press, 1975); the Fried essay, in *Minimal Art,* ed. Gregory Battcock (New York: Dutton, 1968). All Judd and Fried quotations are from these sources. For a more extended discussion of the issues raised here, see my essay "The Crux of Minimalism" (Los Angeles Museum of Contemporary Art, 1986).
2. The two quotations in this sentence are from Robert Morris, "Notes on Sculpture" (1966), reprinted in Battcock. The object-monument range of minimalism is a reference to yet another remark by Tony Smith, in which he suggests that any sculpture under human scale has the intimate address of an object, any above human scale the public address of a monument.
3. This famous phrase, from "Specific Objects," describes the nonhierarchical or serial mode of minimalist composition.
4. See, in particular, Douglas Crimp, "Pictures," *October* 8 (Spring 1979), and Craig Owens, "The Allegorical Impulse: Towards a Theory of Postmodernism," *October* 12 and 13 (Spring and Summer 1980), both reprinted in *Art After Modernism: Rethinking Representation,* ed. Brian Wallis (New York and Boston: The New Museum and David R. Godine, 1984).
5. See, in particular, Benjamin H. D. Buchloh, "Allegorical Procedures: Appropriation and Montage in Contemporary Art," *Artforum* (September 1982).
6. For more on this work, see my essay "Signs Taken for Wonders," *Art in America* (June 1986); and my essay "The Future of an Illusion, or the Contemporary Artist as Cargo Cultist," in *Endgame,* ed. David Joselit (Boston: Institute of Contemporary Art, 1986).

Notes on the Independence Movement

Lucy R. Lippard

Actuality is the interchronic pause when nothing is happening. It is the void between events.—George Kubler

The function of the radical is sacrificial. The radical proposes ideas that cause destruction and later become orthodoxies.—E. L. Doctorow

Art cannot confront society except in acts of originality, which official culture succeeds in absorbing but by which men [people] are nevertheless changed in unpredictable ways.—Harold Rosenberg

Stupid people often accuse Marxists of welcoming the intrusion of politics into art. On the contrary, we protest against the intrusion. The intrusion is most marked in time of crisis and great suffering. But it is pointless to deny such times. They must be understood so they can be ended.—John Berger

We believe the function of the artist is to subvert culture since our culture is trivial. We are intent on giving a voice to the artist who shouts fire when there is fire, robbery when there is robbery, murder when there is murder, rape when there is rape.—The Guerrilla Art Action Group

1967 was the year conceptual art began to surface and news of the Vietnam disaster began seeping into the ivory cubicles of the art world. In Los Angeles, artists erected "The Peace Tower" and successfully debated the war with Rand Corporation hawks. In New York, Artists and Writers Protest organized Angry Arts Week. Ad Reinhardt died, and young conceptual artists dedicated an East Village cooperative, The Lannis Museum of Normal Art, to his "art-as-art." In 1967, Sol LeWitt published "Paragraphs on Conceptual Art," in which he stated influentially: "The idea becomes a machine that makes the art."

The visual art world was a relatively calm island in the swirling tumult of midsixties culture and politics. Although posters were crucial to the creation of a radical sixties image, few "high" artists even considered the medium. 1967 was the year before 1968—"the year of the thwarted revolution." The downswing of The Movement had already begun. The violence and conservatism that lurked beneath the "flowering" of the counterculture was beginning to be co-opted by the mass media, which also divided the Left by creating stars and stereotypes. 1967 was the year of the Watts rebellion, the year Martin Luther King, Jr., began to denounce the war in Vietnam and make the connections between militarism and racism. The Black Power movement was being forced by federal repression into more extreme posi-

tions. Yet on its model, the Women's Liberation Movement was boiling up into public consciousness. There was little in the art galleries or museums that acknowledged any of these events. Not until 1969 did the first spate of artists' political organizations emerge: the Black Emergency Cultural Coalition, the Artworkers Coalition, Women Artists in Revolution. By then, even those artists who chose to be bystanders were implicated by their neutrality. Robert Smithson expressed the common frustration and impotence felt by artists who were trained to think that art had nothing to do with social issues and found themselves overtaken by life, when he wrote in 1970:

The artist does not have to will a response to the "deepening political crisis in America." Sooner or later the artist is implicated or devoured by politics without even trying. . . . If there's an original curse, then politics has something to do with it.

In 1967, John Chandler and I wrote about an emergent "ultraconceptual" or "dematerialized" art, sensing an aesthetic radicalism in the air that might parallel or give form to the political radicalism of the times:

The visual arts at the moment seem to hover at a crossroads that may well turn out to be two roads to one place, though they appear to have come from two sources: art as idea and art as action. . . . The performance media are becoming a no-man's or everyman's land, in which visual artists whose styles may be completely at variance can meet and even agree. As the time element becomes a focal point for so many experiments in the visual arts, aspects of dance, film, and music become likely adjuncts to painting and sculpture, which in turn are likely to be absorbed in unexpected ways by the performing arts. . . . A series is an appropriate vehicle for an ultraconceptual art, since thinking is ratiocination, or discovering the fixed relations, ratios and proportions between things, in time as well as in space.

Unlike other postwar art trends, conceptual art was critically motivated and socially expansive, despite its often uncommunicative facade. The aesthetic questions being asked in 1967 veiled political dilemmas with which artists were just becoming reacquainted. Sated with the media hype and hedonism that accompanied pop art and postpainterly abstraction, awakening from the long, fearful sleep imposed by McCarthyism and the Cold War alienation of art from life, artists were freshly susceptible to a renewed sense of responsibility that incorporated the rejective puritanism of minimalism. A complicated balancing act between nihilism and utopianism was aggravated by middle-class versions of revolutionary morality and the downward-and-outward mobility of the counterculture. Where does art stand in

the world? the soon-to-be-dubbed conceptual artists asked themselves. Why make objects, and for whom? Do artists have to take a stand in the world? If so, where? Should they do it inside or outside of their art and the art context?

From 1966 to 1969 (more or less), conceptual artists shared with the New Left a vision of imminent revolution. Buried in their anti-expressionist, antiromantic, sometimes populist, and sometimes intellectualized works was no less than an urge to change the world by changing perception of the world. "It may be proposed," wrote Hans Haacke as he moved from studying the structures of natural systems to those of social systems, "that the context, or surrounding, of art is more potent, more meaningful, more demanding of an artist's attention, than the art itself." The December 1967 *Artforum* brought Smithson's "Monuments of Passaic," in which he cinematized a dreary urban landscape into an exotic "self-destroying postcard world of failed immortality and oppressive grandeur." Ed Ruscha's accordion book, *Every Building on the Sunset Strip,* had been published in 1966 and was turning artists' heads toward "bad" photography, which, with xeroxed texts, became a staple of conceptual art. Tony Smith's experience of the incomplete New Jersey Turnpike had opened the way for earthworks and site sculpture:

Its effect was to liberate me from many of the views I had had about art. It seemed that there had been a reality there which had not any expression in

This and facing page: CLAES OLDEN-BURG, *The Hole,* Metropolitan Museum of Art, New York. Photographs copyright © by Fred W. McDarrah, New York.

24

art. The experience on the road was something mapped out but not socially recognized.

Sometimes it seemed as though artists themselves were seeing the world for the first time, or trying to give the world back to their audiences simply by saying in their art: "Look! Wow! See that? Feel that?" The idea was that art could help us understand how we see, which would lead to understanding what we see, which would lead to changing what we saw that we didn't like. Escape from the "genius syndrome" of the individual artist and the "precious-object syndrome" of the individual artwork, the "discovery" of the mass-reproducible photo-text piece as a "third-stream" medium led to a reintroduction of daily experience into art and the twin desire to reintroduce art into the world. In 1967, that world did not yet include politics. There were parallels between the external social issues and the internal art debates about identity, framing, and artistic self-determination. But first it was necessary to clean house.

For many conceptual artists, 1967 was a year of the *tabula rasa*. Though nobody was very clear about what the decks were being cleared for, there was an atmosphere of openness and excitement. Artifacts of the period included empty rooms, canceled performances, deleted calendars, transparent film, closed shows, an art school "Chair of Nonentity," air, steam, and gas "sculptures," invisible and impossible "projects," all-white paintings, all-black paintings, xeroxes and snapshots, perceptual experiments, working drawings, newspaper and magazine pieces, artists' books, holes in the ground, maps, graphs, phenomenological descriptions, dictionary definitions, philosophical musings, clues to experiences, ephemeral and throwaway public art, diaries, diagrams, and numbers.

As art-matter was converted into concept on one hand and time-motion on the other, many artists focused on two "new" mediums: print and body, or publication and performance. During the next few years, an extraordinary range of activities took place in which the basic precepts of artmaking were thrown into relief. Unlike the Greenbergian concept of truth to the medium, inseparability of form and content, and formal autonomy dominating the aesthetic object, the conceptual artists deconstructed art to its bare bones (and sometimes to their own bare skin)—to its meaning. Through serialism, analyses of process and procedure, and consciousness of context beyond conventional art spaces, they set in motion an independence movement by which art was to triumph over institutional control.

The aspirations to an "objectless" art combined aesthetic and economic implications. As Marxist theory filtered into the art world, via

The Movement, the French Situationists' concept of "society as spectacle," and the Third World liberation movements, artists began to understand better where they fit into the social system, the importance of image and representation as instruments of social manipulation outside the high-cultural ghetto. As artists considered their own civil rights, political positions, and economic situations, they became increasingly aware of connections between the culture industries and the military-industrial complex, the Rockefellers, Guggenheims, banks, and corporations that had fingers in both pies. (By 1969, even Hilton Kramer right-handedly complimented the Artworkers Coalition for raising "a moral issue which wiser and more experienced minds have long been content to leave totally unexamined . . . a plea to liberate art from the entanglement of bureaucracy, commerce, and vested critical interests—a plea to rescue the artistic vocation from the squalid politics of careerism, commercialism, and cultural mandarinism.")

Throughout the late sixties, swept along on the tides of the time and yet protected by its isolation from the political bitterness of a chaotic Left, conceptual art bowled over one barrier after another. Freed from the bulk and conventional beauty of a controllable commodity, the hitherto infantilized artist struggled to escape from paternalistic critics, curators, and collectors as well as from the elitist isolation of galleries and museums. We dreamed of a time when art would be cheaply and directly dispatched to an unfamiliar and idealized "broader audience." With one radical leap of the imagination, we would escape the physical tyranny of the object and the economic tyranny of the market.

Inspired by the counterculture, artists did their own writing, published their own magazines, opened their own decentralized spaces, set up their own small presses, independent video productions, international networks, and even freed themselves from the restrictions of time and space by street art, mail art, guerrilla art, and such wildly expansive or socially inclusive "dematerializations" as Douglas Heubler's "global" and "duration" pieces, Lawrence Weiner's one-line linguistic clues to the concrete, Ian Wilson's "oral communications," or Robert Barry's telepathic transmissions. Seth Siegelaub's siteless gallery and exhibitions that took place simultaneously all over the world (communicated in catalogue form) was the model for new distribution systems, as was the international distribution of the Artworkers Coalition's "My Lai poster" ("And Babies? And Babies"), after the Museum of Modern Art backed out of its support role. The wit of much conceptual art was applied to political ends, such as the faked mem-

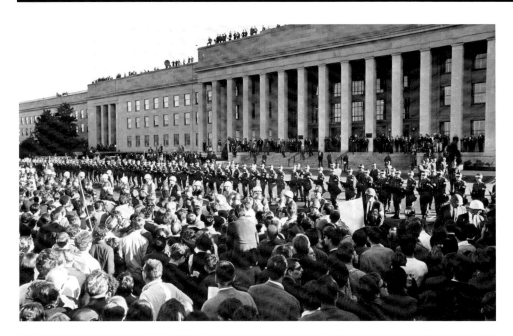

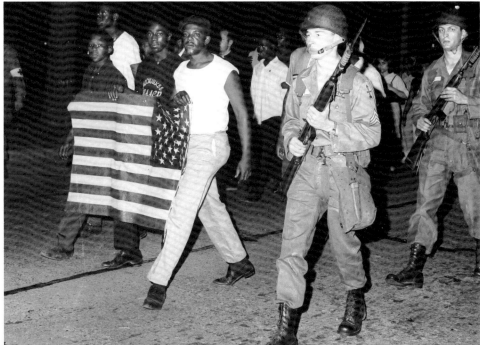

Top: Confrontation at Pentagon: Demonstrators approach lines of U.S. marshals and military police in front of the Pentagon during antiwar rally and march, 21 October. Bottom: Civil rights demonstrators accompanied by National Guardsmen walk to suburban Wauwatosa home of Judge Robert Cannon, whom marchers are asking to resign from a men's club, Milwaukee, 29 August 1966.

bership card to the Museum of Modern Art to protest admission fees, the invitation to a meeting to "kidnap Kissinger" that brought the FBI to the art world, a dime-handout performance in memory of John D. Rockefeller, and the feminist press release purportedly from the Whitney Museum announcing that the 1970 Annual would be 50 percent women and 50 percent nonwhite. The exemplary fusion of art as action and art as idea was the work of the Guerrilla Art Action Group. They were called, like Ad Reinhardt before them and the Guerrilla Girls after them, "The Conscience of the Art World."

The renewed interest in language and linguistic analysis was itself an inherently political move. Among other contributions, it raised new questions about the definition of "propaganda" that are still being debated today. The information fetish that transformed all "facts" into art, and culminated in Kynaston McShine's 1970 "Information" show at the Museum of Modern Art, stimulated knowledge about current events. Artists became more publicly literate as they seasoned their own writings with quotations from new-wave novels, philosophers, and sociologists. Among the culture heros of the time were Borges, Beckett, and Brecht; Merleau-Ponty, Marcuse, and Norman O. Brown; Robbe-Grillet, Sarraute, and Pinget. Contradictions not yet knit into dialectics were rampant; McLuhan ("the medium is the message") and Wittgenstein ("the meaning is the use") coexisted. Artists poised on the edge of the notorious "gap between art and life" argued about energy and entropy, finity and infinity, order and chaos. They looked

"Language to Be Looked at and/or Things to Be Read," installation view, Virginia Dwan Gallery, New York, June.

28

"Language to Be Looked at and/or Things to Be Read," installation view, Virginia Dwan Gallery, New York, June.

out at unknown expanses and made brave statements about taking the leap.

Conceptual art with social awareness was always based on a paradox. While trying to escape the frames imposed by convention and market, the artists nevertheless made framing their prime device for self-containment. The only way they could maintain their "art function" in the wide-open context they desired was to put an art framework over life. They did so in ways that blew the definition of art in many directions and in the process they also defined the limits of art. At its most relevant, conceptual art was part of a much broader movement that eventually included feminism, art activism, and progressive media analysis—many of the components of the most interesting art of the eighties. The common denominator was aroused consciousness—which Herbert Schiller has called "the only reliable force which can lead to change in the material-institutional environment."

In the end, good intentions and unsatisfied desires outnumbered effective interventions in social reality during the sixties. Conceptual art changed forms but not, finally, substance. The illusion that high-art content in new contexts would move large numbers of people had faded by the early seventies. Political content matured artists but left the art institutions relatively untouched. Nevertheless, politicized conceptual art and conceptualized political art continued in the seventies on a grass-roots level and surged into sight again in the middle of the decade. They regained vitality through the feminist art movement, through Artists Meeting for Cultural Change and the Anti-Imperialist

Cultural Union, through publications like *The Fox, the "anti-catalogue," Red Herring, Main Trend,* and *Heresies* (and outside of New York, *Block, Chrysalis, Left Curve,* and *Fuse*).

Reform (not revolution) did occur and the ramifications of events engendered in 1967 are felt in 1987. Women and minorities are better (if still not satisfactorily) represented. The decentralization that the Artworkers Coalition proposed has happened in ways we could not have predicted. The establishment of "artists' turf" in Soho has spread to the further colonization (and gentrification) of Tribeca, the Lower East Side, Brooklyn, Hoboken, the Bronx, Long Island City, and Staten Island. The national decentralization of the art community has also proceeded apace, with national and regional organizations, publications, and spaces all across the country. In 1979, art activists (many working in conceptual forms) took new energy from the surprise uprising of multicultural, multiracial underground, street, and community cultures. Collaboration and collective organizing blazes, burns out, and sparks again almost annually. Artists still daring to mix art and politics are on firmer ground today than they were in the sixties, despite the Reagan administration's censorship and defunding. The history is not entirely forgotten; many of those involved in the sixties have been working ever since; the level of commitment is deeper.

And the frames continue to be stretched. Perhaps the most important legacy of sixties conceptual art to the socialized art of the seventies and eighties is the validation of process over product, with a consequent demystification of art and opposition to restrictive specializations. The process-oriented long-term project that encompasses not just idea and execution but the working process in all its phases—from conception to interaction to effect to self-education and new ideas, new actions—appears as performance or public art or political action. The process of giving form to consciousness never stopped. Disciplinary boundaries crossed and opened in the late sixties never closed back down. Criticism too has been affected. In 1967, Chandler and I wrote that "judgment of ideas is less interesting than following the ideas through. . . . Sometime in the near future it may be necessary for the writer to be an artist as well as for the artist to be a writer."

Only twenty years later, the sixties are already being revived, often as fossil fuel for a fashionable, depoliticized style that includes POMO (postmodernist abstraction, bearing a canny resemblance to sixties minimalism and geometric color painting). Even the best of so-called postmodernism—the scripto-visual, video, and film works that evade academicism and lean to the Left—is part of an unbroken

continuum from sixties conceptualism, especially midseventies post-conceptualism focused on feminist concepts of the ideological function of media representation and consumer analysis. The overworked and underfunctioning concepts of deconstruction and appropriation that originated in the sixties now serve another cycle of anti–precious-object attitudes, similarly displacing notions of originality and individualism to endow art with a critical role in the world.

Postmodernism can be seen as a more aggressive and less idealistic reflection of the cultural imperialism that makes our world go round, the inherited license to take from others that is the operating principle of monopoly capitalism. At best this brings with it an obligation to challenge such assumptions even as they are practiced. In the amnesiac art world, with its dependence on planned obsolescence and the hoopla of stylistic recycling, the progressive motives for trying to escape commodification and control have been blurred. A detailed study of the art of the late sixties would illuminate the darkest alleys of the present, since the customary accent on form has perverted the burning issues of the sixties into a "for-or-against-the-object" position. The fact remains that the dematerialized works of art were important primarily when they succeeded in saying something that couldn't be said as effectively in any other medium. The things that they sometimes said are as undeniably unpopular and significant today, during the Vietnamization of Central America, as they were when artists in 1967 began to dream their art into new places.

Sources

The Artworkers Coalition. *Open Hearing* and *Documents*. New York, 1969.

Chandler, John, and Lucy R. Lippard. "The Dematerialization of Art." *Art International* (February 1968).

The Guerrilla Art Action Group. *GAAG, 1969–1976, A Selection*. New York: Printed Matter, 1978.

Lippard, Lucy R. *Six Years: The dematerialization of the art object from 1966 to 1972* New York: Praeger, 1973.

————. *Get the Message? A Decade of Art for Social Change*. New York: E. P. Dutton, 1984.

Tradition and Conflict: Images of a Turbulent Decade: 1963–1973. New York: The Studio Museum in Harlem, 1985.

Remembering 1967

Barbara Rose

We shall never be again as we were.
Henry James, The Wings of the Dove

For me to try to take an objective view of 1967, as if from an aerial perch, when I was so deeply engaged in the actual skirmishes, would require more distance than I now have. So, rather than attempt any spurious detachment, let me recall what I felt at the time as a partisan participant in a coherent aesthetic dialogue that shortly would become a Tower of Babel free-for-all. Looking at the shift in my own stance and allegiances at the time, I remember most of all a change in mood that affected the art world generally. The spirit of optimism and psychedelic futurism one associates with the sixties in general already had peaked by 1966. The bravado and confidence of the early sixties gradually had been replaced by an introspective attitude of doubt and questioning, particularly on the part of younger artists. In retrospect, and from a totally subjective point of view, 1967 was the year of beginning well that ended badly.

Although Frank Stella had gained a considerable critical reputation, he had not sold a painting out of any exhibition to a private collector until spring 1966 when Christophe de Menil bought *Conway,* one of the eccentric polygons, from his Castelli show. He came home with a bottle of champagne, even though he didn't drink. Suddenly, paintings you could not give away were selling. This permitted Frank to buy a building in which he could have a studio, I could have a study, and our two toddlers could work off their energy. The eccentric polygons were written about widely and seen as a refutation of Stella's initial antiillusionism, as expressed in the flatness of the preceding series of stripe paintings. To the world at large, the eccentric polygons seemed a departure in the new direction of potential illusionism. Actually, Stella had done all the drawings for the eccentric polygons as he smoked cigars in various Basque cafes in Pamplona, Spain, in 1961–62, while I did research on my dissertation. When we returned to America, he showed the drawings to a number of artists, including Ellsworth Kelly, Kenneth Noland, Larry Zox, and Neil Williams, although he did not get around to executing the paintings until 1966–67.

Even though Frank's paintings were, to some extent, selling, we were still in debt to Castelli. It seemed a blessing when we were both offered teaching jobs at the University of California, at Irvine. We left New York for California in January 1967, and rented a house near the campus on the beach at Corona Del Mar. But when they asked Frank to sign a loyalty oath to the Constitution, he refused. (Later, he sued the state of California; he won and was paid for being artist-in-

residence, although he did not teach.) I had already been through this nonsense at Queens College, so signing the same paper again did not strike me as a cause célèbre. Post-McCarthy paranoia was rampant in Orange County, which intensified any existing rift between the artist and society, and my students, like Chris Burden, reacted in extreme performance art that involved bodily risk.

Irvine was the newest branch of the state university system. I shared an office, or rather a whole floor, with John Coplans, the other art history teacher. The rest of the art faculty consisted of Robert Irwin, Larry Bell, Ed Moses, Tony de Lap, and others on the cutting edge of the L.A. avant-garde. In southern California in 1967, art history was something that happened in Europe. The big issue in the east—Is pictorial illusionism an antiquated relic of the European tradition?—simply did not matter. Irwin and Bell already were working with de-materialized light environments, Bengston was painting on metal with automobile lacquer, and Craig Kauffman and Ron Davis had both given up oil and canvas for acrylic paints and plastic supports. The one thing that seemed to have reached California of the meaning of Pollock's art was that a formal revolution only could be attained through a technical revolution. New media and techniques seemed the way to formal breakthroughs. Like "radical" and "revolutionary," "breakthrough" was a late-sixties buzzword. Faith in progress definitely had diminished in the east; out west, though, the idea that technology was a means to invention was the basis of a new aesthetic.

While at Irvine, I wrote the catalogue for the exhibition "A New Aesthetic," which opened at the Washington Gallery of Modern Art in the late spring of 1967. Basically, the text was an elaborate apology for the literalist art of Donald Judd and the California artists Larry Bell, Craig Kauffman, John McCracken, and Ron Davis, the only painter in the show. At the time, I was very involved with the Art and Technology movement, founded by Robert Rauschenberg and physicist Billy Kluver. It seemed possible, although I was not sure even at the time, that the literal object, which inseparably fused color, shape, and structure, was more *advanced* than a painting based on a fictive illusion. Certainly, it was more *real,* the argument went, and, hence, more physically present and demanding in its intrusions into real space.

That painting, in the form given to us by the Renaissance, might no longer be a viable or convincing vehicle for artistic innovation was the burning issue in 1967. As moderator of a series called "The Critic's Colloquium," at N.Y.U., in late 1966 and early 1967, I chose the subject "Is painting dead?" and asked color-field painters Larry Poons and Darby Bannard (now Lawrence Poons and Walter D. Bannard, respec-

FRANK STELLA exhibition, installation view, Leo Castelli Gallery, New York, 25 November–23 December.

tively) to debate minimalist Don Judd and pop-and-assemblage pioneer Robert Rauschenberg. Poons and Bannard, who was among the artist-polemicists who wrote eloquently and convincingly, hewed predictably to the Greenbergian line, praising stained abstraction as the only legitimate heir to Pollock's legacy. Judd reiterated his "specific objects" argument, which he had published as a theoretical position to be reckoned with. Rauschenberg, typically, was willing to have everything go on at once in the spirit of democratic cross-pollenation. Once again, the issue, basically, was the opposition of the literalist object to the painted illusion.

I was interested in both minimal and pop art, and had given them historical importance in my textbook *American Art Since 1900,* published in early 1967, but up until that time my critical writing was still much indebted to Clement Greenberg. With Phil Leider as editor, *Artforum* was still a cozy club, and its contributing editors—Max Kozloff, Sidney Tillim, Rosalind Krauss, Annette Michelson, Michael Fried, and myself—were still speaking. By the end of 1967, we were speaking less. Battle lines had been drawn: You had to make up your mind whether you still believed that Greenberg was gospel. Annette, who had returned from Paris the previous year to live in New York, and Max had already attacked Greenberg's position earlier in articles in *Art International.* If I could sum up the shift that occurred in art and criticism in 1967, it would be the widespread assault on the dogma of modernism as an exclusively optical, art-for-art's-sake, socially detached, formalist phenomenon that inevitably tended toward abstraction and the elimination of drawing as a separable element used to depict shapes against a field. Now, edge, too, demanded to be literal.

One by one, we would all, except for Michael Fried, find ourselves opposed to the rigid exclusivity of Greenberg's narrowing vision, which appeared increasingly inadequate to deal with what artists actually were doing. Seeing Pollock's paintings at the MOMA retrospective that year revealed how thin and limited was the work of the school of postpainterly, lyrical, stained color-field abstractionists championed by Greenberg. Suddenly, nothing seemed certain, not even the sacred teleology of mainstream modernism. Undoubtedly, the escalation of the Vietnam War, and the artists' opposition to that event, contributed to the mood of skepticism, as did the increasingly commercial attitudes of dealers and collectors. Although pop had created a media sensation when it first appeared, American art did not take off on an international scale until the late sixties. The unexpected influx of money into what had been a relatively closed, nonmaterialistic milieu, involved with questions of aesthetics and

3

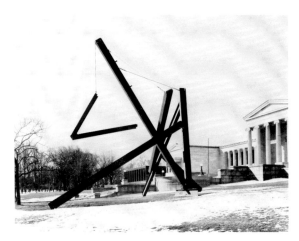

transcendence, came as an abrupt shock, unmasking utopian positions as banal rhetoric. The attack of conceptual art on any kind of object—literal or illusionistic—was a response to the economic realities of art as a commodity, a kind of brightly colored trading bead used as exchange currency in the markets of the global village. The megalomania of earthworks was matched by the opposing low profile of ephemeral or provisional art that could simply be swept up or stacked away when not on view. The deliberate debasing of the status of art as a higher calling, and the stripping away of any metaphysical pretensions, was part of an effort, which now seems to me extraordinarily shallow, to democratize art.

The once-hated bourgeoisie, meanwhile, was hot on the heels of the avant-garde. The question became, what could be so obviously valueless, unappetizing, unpleasant, or boring as to throw the non-participating voyeurs off the scent? With artists equating the museum-gallery complex with the military-industrial complex, there was an attempt to make art that went beyond the confines of the elitist museum or refused to play the role of polite salon decor. Public sculpture, by artists such as Calder and di Suvero, aimed at a status more elevated than that of the trading bead. Unstable structures of rough, raw materials, by young sculptors like Richard Serra, or quirky, highly personal, emotional, and subjective objects, such as those being produced by Eva Hesse, the only young woman taken seriously at that time, also challenged the idea of the "beautiful." For the moment, their art was still more or less underground, although Serra and Hesse were to emerge as leading forces in the seventies, and their postminimal art of metaphor and meaning would represent a direct challenge to the deadpan obtuseness of minimal art.

Back in California, Frank and I were having kite-flying parties on the beach for the L.A. artists who came to visit us. Frank had begun to work at Gemini, G.E.L., and to make his first lithographs. He also had a painting studio in Costa Mesa, where he painted the last and largest of the copper-stripe paintings, *Sangre de Cristo*. He had already completed the drawings for the first series of Protractor paintings the previous year, while we were vacationing in St. Thomas on borrowed money, but he did not start to execute them until we moved into the new building in late spring 1967. Although these still were shaped canvases, the circular arabesques and emphasis on color relationships were a clear bow in the direction of Matisse and the decorative style. That summer, Frank had a job directing the Emma Lake workshop in Saskatchewan, Canada. Apparently, Barnett Newman, who had been an earlier director, and the Canadian sculptor

MARK DI SUVERO, *Are Years What? (For Marianne Moore)*, steel, 480 x 480 x 360, installation view, Albright-Knox Art Gallery, Buffalo, New York.

Robert Murray, who was a friend, had recommended Frank. In that exquisitely beautiful and unperturbed landscape, Frank painted his most open, relaxed, Matissean lyrical paintings, which were named after such places as Lac la Ronge and Flin Flon. The paintings were conventional rectangles, clearly within the tradition of modernist painting. Although they were the beginning of the Protractor series, they had a peaceful, open quality and degree of spatial, atmospheric illusionism unknown to literalist shaped paintings.

In New York that autumn, Frank resumed the Protractor series. These were tense, impacted, cut-out, curved, antiillusionistic shaped paintings. I began work on a monograph on Claes Oldenburg, whose art I saw as key to the development of a new sensibility that opposed the rigid and the doctrinaire in any of its forms. Oldenburg's work, I believed, contained a subtly critical conceptual element that, nevertheless, did not call for giving up art-making as a proof of moral purity. Two events, however, had changed my life and certainly the direction my writing would take. The first was the end of my close friendship with Michael Fried, whom I considered clearly the best critical mind of my generation. By 1967, when he published "Art and Objecthood"— a brilliant attack on any form of literalism or theatricality in visual art— and I published the catalogue *A New Aesthetic,* defending the literalist antiillusionism of Judd and the L.A. School, we were obviously so ideologically opposed, dialogue was no longer possible. I could not understand refusing to deal with new art that did not conform to some idealist notion of a mainstream of modernist reductiveness. The idea that an art form defined itself by focusing exclusively on the essence of its medium seemed too narrow.

More painful, even, than the loss of Michael's encouragement and criticism, however, was the death of Ad Reinhardt. Ad had been friend, mentor, father figure, and moral exemplar, as well as an important stimulus to my writing. The 1966 exhibition of his "black" paintings at the Jewish Museum revealed him to be the calculated polar antithesis of Pollock, as extreme in his elimination of color, drawing, and movement as Pollock had been in his radical techniques and gestural physicality.

Intellectual, contemplative, academic—in the positive sense of a sophisticated and disciplined intelligence—Reinhardt represented the *vita contemplativa* in opposition to Pollock's *vita activa.* Yet, both lived hard and died young, just as their art was about to gain public acclaim. Pollock did not live to see what Irving Sandler has termed "the triumph of the New York School," but Reinhardt was appalled by it. He was against art that could be reproduced, and up in arms about

Andy Warhol's obvious manipulation of mass media. Reinhardt believed, above all, that the morality of the modern artist consisted of the negation of bourgeois values and the status quo. His stern opposition to decorative art as a palliative distraction—and investment for the status conscious—influenced the leading artists of several younger generations. His statement, "This is your painting if you paint it," regarding his identically sized and, on superficial view, identically colored black paintings, certainly encouraged Carl Andre and Dan Flavin to use cheap standard units easily acquired in their environmental installations; and his aggressive, negative, antibourgeois stance undoubtedly had its effect on such artists as Richard Serra and Robert Smithson.

In his lifetime, Reinhardt published a good deal of polemical material. We had been discussing doing a collection of his writings when he died of a sudden heart attack at the age of fifty-four. I immediately began work on the project, feeling it was my obligation to put his work and thought in perspective. The task took up most of my time in the next year. Conceptual art, I felt, was basically a continuation of Reinhardt's questioning of means and ends, intentions and values. I tried to deal with it as a phenomenon that could be evaluated critically—judged, at least, with regard to its success or failure as an argument. For as long as one continued to make value judgments, criticism remained a valid occupation. I was determined not to be closeminded about developments I personally could not predict.

One of those developments certainly was earthworks. However, I saw them at that point and still, for the most part, see them (with the exception of Michael Heizer) as basically conceptual events made concrete, at least temporarily, since nature is not as protective a conserver as the art museum. The emergence of Robert Smithson in 1967 as an important voice, a writer of immense talent and a witty antagonist to formalism, was an event of importance. When I first met Smithson, he was drawing Hell's Angels-type motorcycle imagery and dressing in protopunk leather. In writing and polemics that focused on the pressing issue of ecological catastrophe, he found himself. He was the center of a scene, however, in which I played no part; my sympathies were still with the purportedly moribund arts of painting and sculpture.

The truth is, I no longer felt myself part of any scene. I may have been learning a lot about film and theory from Annette Michelson, whose sophisticated critical intelligence left no received idea unquestioned, but if I was associated in any way with art as the focus of group/social life, it was strictly in working with the artists and critics—

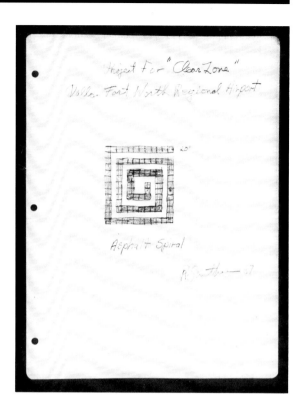

Robert Smithson, *Project for "Clear Zone," Dallas–Fort Worth Regional Airport,* pencil on graph paper, 11 x 8½.

GEORGE SEGAL, *Execution,* plaster, wood, 96 x 132 x 96, collection Vancouver Art Gallery, Vancouver, Canada.

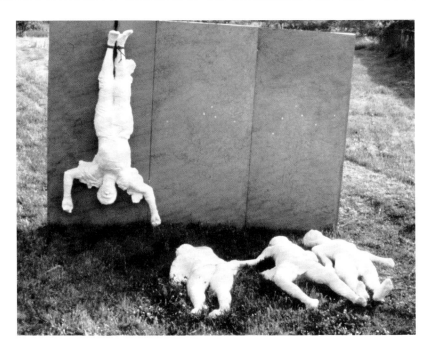

led by Max Kozloff, Irving Petlin, Lucy Lippard, and Robert Morris— opposed to the Vietnam War. Real-life demonstrations took over where playful happenings left off. When I left the house, which had become for me a protective family sanctuary, a fortress against the outside world, it was to tape interviews with Oldenburg and his wife, Pat, in their new, big, Broome Street loft not far from where we lived, or to work with Ad's widow, Rita Reinhardt, organizing his papers for publication. Sometimes I went east, across Houston Street to the former bank Jasper Johns bought after his studio in Edisto, South Carolina, burned down. I liked to watch him working slowly and painstakingly at Tanya Grosman's Universal Limited Art Editions out on Long Island, away from the city noise. There, I saw him begin the immensely complex project that would become the prints and painting called *Decoy.* Johns's reticence, craft, and precision seemed to me the opposite of where the art world was going. By that time, the demand for his work was enormous, but in 1967 he painted only four new paintings and finished two pictures he had started earlier. Other artists, however, had set up their studios as assembly-line production facilities, based on Warhol's idea of the "factory."

Initially, I had been fascinated with Warhol. I spent a lot of time at the original Factory because there were a limited number of places

you could go with a baby, and at the time I couldn't afford a babysitter. But I was distressed by the nihilism and passive collaboration with materialism and commerce. The atmosphere in the Factory had changed, too. There were now more calculating, would-be media stars than mad, aspiring poets. The sounds of Nico's gutteral androgynous monotone and the grating drone of the music of the Velvet Underground were more subtly vicious than Pope Ondine's most outrageous diatribes. The nastiness of punk was already in the air and a sense of imminent violence made the place unpleasant. Warhol had started giving more interviews, claiming that art should be easy, not difficult, yet another attack on the status of art as a privileged object. Between Warhol's embrace of easy undemanding art and Judd's contention that art need only be interesting, the critical dialogue, based on distinctions of value that sought primarily to identify *quality,* seemed not just irrelevant but impossible to continue; there was no longer a single language derived from an educated philosophic point of view, just a multitude of conflicting and contradictory neologisms. Quality was replaced by quantity. That went for the yards of stained canvas bearing the Greenbergian seal of approval flooding the market as much as for Warhol's dumb boxes, which were minimal art with a pop facade. Strategy replaced intuition: The worst were filled with passionate intensity, while the best were beginning to lack conviction, or, at least, a voice. Reams of printed matter, from conceptually oriented magazines like *The Fox* and *Avalanche,* inundated the art world. Politics replaced aesthetics as a focus. Successful artists withdrew into themselves and the internal meditation of an isolated subjectivity. The common language of high culture was assaulted as inaccessible. Many artists ceased viewing the bourgeois public as the enemy whose values were different from their own and began cafe-society social climbing and seeking rather than shunning publicity.

All these changes made the art world a different place from what it had been for the New York School. By the end of 1967, I was locked into my library and my own thoughts. I had lost two of my closest ties to the art world when Michael Fried and I drifted apart and Ad Reinhardt died. The idea, still prevalent and tenable in the early sixties, that art could change the world, seemed evidently ludicrous. The success of the avant-garde coincided with its demise. The utopian project, the faith in at least moral if not material progress, seemed, in the face of the realities and atrocities of the undeclared war and man's destruction of the environment, a remote, romantic dream. Things would never be again as they once were.

1967: Out of Minimal Sculpture

Irving Sandler

Why 1967? Why not 1959, the year Frank Stella's black-stripe paintings, exhibited in Dorothy Miller's "Sixteen Americans," at the Museum of Modern Art, stunned the New York art world and, in retrospect, would seem to mark the end of abstract expressionism as *the* avant-garde tendency? Or 1962, the controversial onset of pop art? Why not 1964, the year Clement Greenberg's "Post-Painterly Abstraction," at the Los Angeles County Museum of Art, heralded the recognition of stained color-field and hard-edge painting? Or 1966, when Kynaston McShine's "Primary Structures," at the Jewish Museum, featured minimal sculpture, or 1970, when his "Information," at the Museum of Modern Art, "established" conceptual art in America? Provocative shows might have been put together on the theme of 1959 or 1962 or 1964 or 1966 or 1970, or almost any year in between. Each would have looked different, so fast was the tempo of style change in

ARTFORUM

SPECIAL ISSUE SUMMER 1967

AMERICAN SCULPTURE:

COVER: Larry Bell, Memories of Mike, metal and glass, 24" square, 1966-7. (Color courtesy Pace Gallery, New York. Photo: Ferdinand Boesch.)

PublisherCharles Cowles
EditorPhilip Leider
Associate Editor (L.A.)John Coplans
Contributing EditorsMichael Fried
Max Kozloff
Annette Michelson
James Monte
Barbara Rose
Sidney Tillim
Production Eddie Russia
CirculationSusan Ruth Davis
Executive SecretaryTanya Neufeld
ARTFORUM, Vol. V number 10, June 1967. Published monthly except July and August at 667 Madison Avenue, New York, N.Y. Subscriptions $10 per year, $12 foreign. Newsstand distribution by Eastern News Distributors, 155 W. 15th Street, New York, and US Distributors, 552 McAllister St., San Francisco.
ADVERTISING
New YorkPaul Shanley
663 Fifth Avenue
421-2659
EDITORIAL & BUSINESS OFFICES
667 Madison Avenue, New York, N.Y. 10021
Volume V, No. 10, June, 1967. Published Monthly except July and August. Second-class postal rates paid at Los Angeles, Calif. Contents may be reproduced only with the publisher's written permission.

Throughout this issue, all captions marked with an asterisk (*) indicate that the work reproduced is included in the exhibition American Sculpture of the Sixties organized by Maurice Tuchman for the Los Angeles County Museum of Art and shown there from April 28 through June 25, 1967.

Facing page, top: BRUCE NAUMAN, *From Hand to Mouth,* wax over cloth, 30 x 10 x 4.
Facing page, bottom: ROBERT MORRIS, Untitled, stainless steel, 96 x 96 x 24, collection Philip Johnson.

the sixties. "Make it new" was truly the art slogan of that decade.

But why 1967? Because it was a watershed year. The minimal sculpture of Donald Judd, Robert Morris, Dan Flavin, and Carl Andre, and its premises, had become *familiar,* at least to the art world, through shows in private galleries and articles by Judd, Morris, Barbara Rose, Lucy Lippard, among others. This is not to say that minimal sculpture of high quality was no longer being made. On the contrary, much of the best was yet to come. But it had ceased to be in the vanguard. That role was assumed by a number of innovative late-minimal artists, such as Eva Hesse, Richard Serra, Robert Smithson, and Bruce Nauman. I use the term "late minimal" rather than "postminimal" because minimal art remained the aesthetic context of late minimalism, whereas postminimalism aimed to cut its throat. As a watershed year, 1967 should not be too rigorously delimited; it should be allowed to reach back in time to 1966 and forward to 1968.

What then exemplified 1967? When I began this essay, what jumped into mind—and stayed in mind—was the special issue on American sculpture of *Artforum* that appeared in the summer. At that moment, its editor, Philip Leider, had his finger on the pulse of the liveliest art in the United States and its issues, and he attracted many of the liveliest writers to deal with it: Robert Morris, Robert Smithson, and Sol LeWitt (who, as artists, are in the "1967" show), and critics Michael Fried, Barbara Rose, and Max Kozloff, among others. Leider himself introduced the issue with a critical article on Maurice Tuchman's "American Sculpture of the Sixties" survey, at the Los Angeles County Museum of Art, which, as I recall, was *the* show of the year. It is fitting that the special issue featured sculpture, since it seemed to be the foremost art. So dominant was sculpture in 1967 that a hotly debated topic in the New York art world was, "Is painting dead?"

The basic premises of minimal art were recapitulated in the special issue by Morris, an innovator of minimal sculpture who had become its leading aesthetician. In his "Notes on Sculpture, Part 3: Notes and Nonsequiturs," he wrote that minimal sculpture had zeroed in on what made it sculpture-as-sculpture, namely its *literal* objecthood: "the shape becomes an actual object against the equally actual wall or ground." The common elements of minimal sculpture were "symmetry, lack of traces of process, abstractness, nonhierarchic distribution of parts, nonanthropomorphic orientations, general wholeness." Morris not only considered three-dimensional work fundamentally different from painting (or any other art, for that matter), but he dismissed painting as an "antique" mode. But what interested Morris more than the definition of minimal sculpture in 1967 were its unex-

pected consequences: non sequiturs. Because a minimal object lacks internal relationships, it sets them up with its surroundings. In moving about, viewers become acutely aware of its "spatial setting." Glimpsing different views of the object in changing light alters their perception of the object and its and their environment or *situation*.[1]

Tony Smith was also speculating about the environment and art. In an interview about his sculpture in 1966, he digressed to talk about a drive he had taken one night on the unfinished New Jersey Turnpike. The road and its surroundings had overwhelmed him as no conventional art ever had. And yet, such phenomena were not designated as art. Smith remarked: "I thought to myself, it ought to be clear that's the end of art. Most painting looks pretty pictorial [meaning conventional] after that." But he could conceive of no way that his experience of the landscape could be translated into art.[2] Smith's problem was soon to be taken up as a challenge by Smithson (the sequence of names is coincidental, of course) and other artists of his generation.

Morris's text in *Artforum* was accompanied by reproductions of his own work and that of Judd, Flavin, Andre, LeWitt, Larry Bell (whose work was considered in an article by Fidel A. Danieli), and John McCracken. By 1967, their work had eclipsed formalist sculpture —that is, the welded metal construction of Anthony Caro and his followers. But construction sculpture continued to be very much admired for its quality in avant-garde art circles, and Leider featured it in articles on David Smith, by Jane Harrison Cone, and Mark di Suvero, by Kozloff.[3]

In response to the minimalist challenge, Fried took up the standard of formalist art, or modernist art as he called it, in the special issue, in an urgent polemic entitled "Art and Objecthood." Fried was not only concerned with the avant-garde's loss of interest in formalist art but with the way in which minimalist partisans used formalist premises, formulated by the leading formalist critic, Clement Greenberg, to justify minimal sculpture. Greenberg had stated that in the modern era each of the modernist arts had turned in on what made it autonomous and unique as an art. In painting, therefore, he preferred the work of Kenneth Noland and Jules Olitski, which asserted the two-dimensionality of the picture's rectangular surface and the opticality of color. In sculpture, however, he favored open, welded construction —the tradition that extended from Picasso and González through David Smith to Caro—which he claimed was essentially "pictorial" because it was based on "drawing" in space with linear and planar elements.

Morris viewed Greenberg's preference in sculpture as a denial

of Greenberg's own formalist premises. Morris asserted that the nature of sculpture-as-sculpture was *not* to be pictorial as was painting-as-painting. Instead, sculpture-as-sculpture should approach the object, articulating its obdurate, physical mass. Because minimal sculpture did so, Morris declared that it was the *legitimate* latest stage of modernist sculpture. Fried met this argument by pointing to a contradiction in Morris's polemic: Minimal objects, which Fried called literalist objects, invariably directed the viewer's attention to the environment in which both the work and the viewer were located, thus subverting the autonomy of the art work. He found this situation inherently *theatrical,* since the viewer, now very conscious of him- or herself, became a kind of actor.

Fried went on to say that "there was a war going on . . . between the theatrical and the pictorial." As a formalist, he had come to value the pictorial, both in painting *and* in sculpture, above all else in art. As foes of the pictorial, the minimalists were enemies of "the authentic art of our time"; more than that, *of art itself*. The mission of both painting and sculpture, as Fried saw it, was to defeat objecthood. That, in his opinion, was what Caro had achieved in sculpture, and Noland, Olitski, and Stella in painting. Stella was of particular importance to Fried. His painting had been the primary influence on minimal sculpture, yet, in 1967, Stella verged toward stained color-field painting. Without abandoning his concern with *shape,* which had been the preoccupation of minimal sculpture and which, according to Fried, had become the main concern of recent formalist painting, he resorted to *illusionism,* which, by its nature, was antiliteralist. Painting could now have it both ways and was, therefore, not "antique" or outmoded, as Morris claimed, but, quite the contrary, superior to minimal objects. And so was construction sculpture, because it approached the pictorial.

So avid was Fried in his war against objecthood that he denied the old formalist distinctions between sculpture-as-sculpture and painting-as-painting. Instead, he sought for a common denominator of both, some quality found in no other art, and discovered it in "presentness." An art that possessed presentness "has no duration . . . because at every moment the work is wholly manifest." In contrast, minimal sculpture had "presence," a kind of stage presence; it was experienced in time. Because it was "instantaneous," formalist paintings and sculptures had won out over minimal objects.[4] And they would also vanquish theatrical "art" without the object, the kind of phenomena that occurred to Tony Smith during his nocturnal automobile ride on the New Jersey Turnpike.

Today, it is difficult to imagine how urgent such issues as for-

ALLAN KAPROW exhibition, "Words,"
environment installation view, Pasadena
Art Museum, Pasadena, California,
15 September–22 October.

malism versus literalism were in the sixties, certainly to the artists in-
volved and their critic and curator supporters. And the intensity of the
polemics contributed to the enterprise of all parties, although to out-
siders it could seem esoteric and convoluted. In a letter to *Artforum*
on Fried's article, Allan Kaprow, surely one of the most sophisticated
artists of the time, wrote: "All that talk about fighting between 'literalists'
and 'modernists.' First I heard of it. Maybe . . . [Fried is] in on some
plot or something."[5]

Formalism did not win its war against minimalism, of course.
Neither did it lose. By 1967, both had won; they had become estab-
lished. But it was literalism in art that continued to engage the most

4

interesting of emerging artists. At the same time, they were doubtful that minimal sculpture could be extended in fresh ways. Indeed, it was natural in a decade in which "make it new" was a cardinal value for a reaction to have set in. In 1966, Lucy Lippard, an advocate of minimal sculpture, acknowledged:

The conventions of this mode are already established. . . . It must have looked easy when Don Judd, then Robert Morris, and later Sol LeWitt and Carl Andre began to attract attention, but the mold hardened fast for their imitators. Monochrome, symmetry, single forms, stepped or graded color or shape, repetition of a standard unit, the box, the bar, the rod, the chain, the triangle or pyramid, are the new clichés.[6]

Lippard claimed that the rigors of minimalism had made her aware of what it precluded, namely "any aberrations toward the exotic."

Yet in the last three years, an extensive group of artists on both East and West Coasts, largely unknown to each other, have evolved a . . . style that has a good deal in common with the primary structure as well as, surprisingly, with aspects of surrealism. [These artists] refuse to eschew . . . sensuous experience while they also refuse to sacrifice the solid formal basis demanded of the best in current nonobjective art.[7]

More specifically, Lippard had in mind such artists as Louise Bourgeois, Eva Hesse, Kenneth Price, Keith Sonnier, and H. C. Westermann, artists she included in a show entitled "Eccentric Abstraction" that she organized at the Fischbach Gallery in the fall of 1966. The central artists, such as Hesse, retained minimalism's rational modular or serial gridlike structure and literalist treatment of new, unexpected, often floppy materials, while giving rein to irrational, even absurd, autobiographical, psychological, erotic impulses—above all, erotic, because of the soft materials used—as well as other surrealist or expressionist impulses. Their late-minimal work was aptly characterized as minimalism with an eccentric edge, or a dada or surrealist edge, purist funk, or a sexy minimalism.

The special issue did not deal with any of Lippard's eccentric abstractionists, but Leider, responding to the same aesthetic stimuli as Lippard, published Barbara Rose's article on Claes Oldenburg's extravagant soft sculptures of common objects. In her introductory sentence, she proclaimed that "Oldenburg is the single pop artist to have added significantly to the history of form."[8] Lippard stated that his "flowing, blowing, pokeable, pushable, lumpy surfaces and forms"[9] were the primary influence on eccentric abstraction. *Artforum,* in an article by James Monte, also featured eccentric abstraction's

CLAES OLDENBURG, installation view, "Proposals for Monuments," Sidney Janis Gallery, New York, May.

San Francisco counterpart, funk art. In opening up to surrealism and expressionism, eccentric abstraction and funk art eased the way for the recognition of sixties mavericks, among them Lucas Samaras, whose boxes, objects, and reliefs, studded with pins, razors, and other threatening phenomena, are autobiographical—and pervaded with pain. In 1967, Samaras turned benign and began to translate commonplace objects into fantastic and witty works that evoked what the surrealists called the "marvelous."

Morris's work took a late-minimal eccentric or funky turn in 1967 —in a series of cut-felt pieces. The pattern of slits remained geometric and modular, as in his minimal sculptures, but the geometry was subverted by the random sprawl of the soft materials, which called atten-

tion to the literal *process* of sprawling. In 1968, Morris wrote an article in *Artforum* entitled "Anti-Form." (The label was coined by Leider, not Morris, who objected to it.) Morris claimed that minimal art was not as physical as art could be or should be because the ordering of its modular or serial units was not inherent in the materials themselves. To make the work more literal, the process of its "making itself" had to be articulated. Morris, therefore, called for an art whose focus was on variable matter itself and the action of gravity upon it. Such an art could not be predetermined; its order was "casual and imprecise and unemphasized. Random piling, loose stacking, hanging, give passing form to the material. Chance is accepted and indeterminacy is implied since replacing will result in another configuration."[10] Thus, Morris turned against his minimalist preoccupation with preconceived, clearly defined, and durable unitary volumes, but not with its stress on literalness.

The major process artist to emerge was Richard Serra. In 1967–68, he compiled a long list of verbs of action: "to roll, to crease, to fold, to store, to bend, to shorten, to twist, to twine, to dapple,"[11] and so forth, a number of which he soon would execute, as in his lead spatter pieces, prop pieces, and scatter pieces. Process art would lead to filling interior spaces with a variety of substances, often inchoate—for example, earth. From these indoor environments, it was but a short step outside, into nature—into earth art.

Smithson, who emerged as a formidable polemicist in 1967, wrote a letter to *Artforum* rebutting Fried's "Art and Objecthood," taking issue with, among other matters, the attack on Tony Smith, whom Smithson hailed as "the agent of endlessness."[12] Challenged by Smith's speculation about the aesthetic potential of an "'abandoned airstrip' as an 'artificial landscape,'" lacking in "'function' and 'tradition,'" Smithson had the opportunity of trying to find a frame for the kind of amorphous sensations experienced by Smith when Smithson himself became an artist-consultant to a firm of engineers and architects developing an air terminal in Texas between Fort Worth and Dallas. Smithson's observations appeared in the special issue in an article entitled "Towards the Development of an Air Terminal Site." In the process of investigating the site, auger borings and core borings were made. These soil samples intrigued Smithson, as did "pavements, holes, trenches, mounds, heaps, paths, ditches, roads, terraces, etc., [all of which] have an aesthetic potential" and are "becoming more and more important to artists." Instead of installing works of art in the airport, Smithson proposed to take the entire site itself into account, its physical and metaphysical dimensions beneath

the earth, on the ground, and from the sky. "One does not impose, but rather exposes the site." Smithson envisioned other "art forms that would use the actual land as a medium"—in remote places, such as the Pine Barrens of New Jersey or the North and South Poles. "Television could transmit such activity all over the world."[13] Smithson concluded, prophetically, that site-specific earth art was just beginning.

And indeed it was—for Christo, Walter De Maria, Michael Heizer, Dennis Oppenheim, and Smithson. In 1967, Oldenburg had his notorious *The Hole,* a "grave," dug and filled by gravediggers in Central Park. This work was executed for "Sculpture in Environment," one of the early shows of works of art in public places in America. Oldenburg also exhibited his "Proposals for Monuments": *Fagends* and *Drainpipe Variations,* at the Sidney Janis Galley, in New York, and *Giant Wiper* and other "Proposals," at the Museum of Contemporary Art, in Chicago. Both *The Hole* and the "Proposals" anticipated the renaissance of public art in the United States.

Smithson was particularly fascinated by the aesthetic potential of disintegrating matter—sediment, sludge, and the like—verging toward a state of entropy, which, as he saw it, was the destiny of the universe. Conceptual art was another kind of "dematerialization," to use Lippard's and John Chandler's term.[14] The seminal statement, "Paragraphs on Conceptual Art," by Sol LeWitt, appeared in the special issue. It is fitting that conceptual art should have been treated first in the context of sculpture, since, in its original late-minimal form, it is a dematerialization of the primary structure, taking it back to the original idea that generated it and presenting the idea itself in verbal form as an artwork.

LeWitt defined conceptual art as art that "is meant to engage the mind of the viewer rather than his eye or emotion." He went on to say that "the idea or concept is the most important aspect of the work. When an artist uses a conceptual form of art, it means that all of the planning and decisions are made beforehand and the execution is a perfunctory affair. The idea becomes a machine that makes the art." That did not mean that conceptual art was rational, "theoretical or illustrative of ideas." Quite the contrary, "It is intuitive . . . and it is purposeless." Conceptual artists "leap to conclusions that logic cannot reach. . . . Irrational judgments lead to new experience." But conceptual art avoided the subjective process of art-making. "Once the idea of the piece is established in the artist's mind and the final form is decided, the process is carried out blindly."

Conceptual art was the antithesis of art "that is . . . perceptual rather than conceptual." LeWitt's antipathy to the physical led him to

entertain the idea of a purely conceptual art:

If the artist carries through his idea and makes it into visible form, then all steps in the process are of importance. The idea itself, even if not made visual, is as much a work of art as any finished product. All intervening steps—scribbles, sketches, drawings, failed works, models, studies, thoughts, conversations—are of interest. Those that show the thought process of the artist are sometimes more interesting than the final product.[15]

Thus, conceptual art could range from an object generated by an idea to a written or verbal proposal, or it could exist in the gap between verbalization and visualization. Illustrations of his own works accompanied LeWitt's article, as well as those of Jo Baer, Ruth Vollmer, Flavin, Andre, Mel Bochner, Hesse, Jane Klein Marino, Paul Mogensen, Edward Ruscha (a detail from *Every Building on the Sunset Strip*), and Dan Graham (a photograph of steps). Conceptual works by LeWitt, Tony Smith, Bochner, and Brian O'Doherty were included in an issue of *Aspen Magazine,* no. 5 and 6, edited by O'Doherty, in 1967. This particular issue was a box that contained not only conceptual art but essays, fiction, recorded music and statements, interviews, documents, poetry, and films by Robert Morris, Stan VanDerBeek, Robert Rauschenberg, Marcel Duchamp, Samuel Beckett, William Burroughs, Alain Robbe-Grillet, Roland Barthes, John Cage, Merce Cunningham, and Dan Graham, among others. Unlike Leider, O'Doherty dealt with broader intellectual issues that engaged artists in the late sixties, a topic too large to be dealt with in this essay. (Also illuminating was a series of statements by artists that Barbara Rose and I compiled and published in *Art in America,* in 1967.[16] I still feel it is the best summation of the sensibility of the sixties.)

With the advent of process art, earth art, and conceptual art around 1967, other tendencies—for example, the new realism of Alex Katz, Philip Pearlstein, and Alfred Leslie—began to vie successfully for recognition. Art became increasingly pluralistic. Leider's special issue contained articles on realist sculptors—George Segal, by Robert Pincus-Witten, and Richard A. Miller, by Sidney Tillim—and on Ellsworth Kelly as sculptor, by Barbara Rose. Even within minimal art there were diverse developments, notably the monumental primary structures of Tony Smith and Ronald Bladen that emerged with a strong profile in 1966–67, and the dematerialized minimal sculpture of Larry Bell. There was a general tendency toward complexity—exemplified in painting by Stella and Roy Lichtenstein and, even more, Al Held, and in sculpture by the polychromed, laminated wood constructions of George Sugarman. The new pluralism called into ques-

tion the avant-garde imperative "make it new," an imperative that led artists to press to the limits of art, limits that were reached when art came close to looking like nonart, as process art, earth art, and conceptual art did when they first appeared. Perhaps the last word had been said by conceptual artists who "eliminated what may be irreducible conventions in art—the requirements that it be an object and visible." By 1969, it was clear, at least to me, that the audience for art

may have to change some of its expectations. It may have to stop considering novelty in art as a primary value. Rather, it may have to attach greater importance . . . to the expressiveness and uniqueness with which artists mix visual ideas. The possibilities in art today are endless. There are areas of vast potential—scarcely tread by those artists who have jumped to extremes—that require fuller exploration. The audience for art objects has also to become open as never before to multiple tendencies in art.[17]

In retrospect, 1967 marked the beginning of the end of the sixties, of the avant-garde as a believable concept, perhaps even of modernism, and the ICA exhibition should be considered with this in mind.

Facing page: RONALD BLADEN, *The X,* installation view, wood, 264 x 312 x 168, Corcoran Gallery of Art, Washington, D.C., collection Patrick Lannan.

Notes

1. Robert Morris, "Notes on Sculpture: Part 3, Notes and Nonsequiturs," *Artforum* (Summer 1967): 25–26.
2. Samuel Wagstaff, Jr., "Talking with Tony Smith," *Artforum* (December 1966): 19.
3. An article on Anthony Caro did not appear in the special issue of *Artforum,* presumably because his work was the subject of an article by Michael Fried in the February issue.
4. Michael Fried, "Art and Objecthood," *Artforum* (Summer 1967): 22.
5. Allan Kaprow, "Letters," *Artforum* (September 1967): 4.
6. Lucy R. Lippard, "New York Letter: Recent Sculpture as Escape," *Art International* (20 February 1966): 20.
7. Lucy R. Lippard, "Eccentric Abstraction," *Art International* (November 1966): 28.
8. Barbara Rose, "Claes Oldenburg's Soft Machines," *Artforum* (Summer 1967): 30.
9. Lippard, "Eccentric Abstraction," 36.
10. Robert Morris, "Anti-Form," *Artforum* (April 1968): 34–35.
11. Richard Serra, "Verb List Compilation 1967–1968," in Gregoire Muller (text) and Gianfranco Gorgoni (photographs), *The New Avant-Garde: Issues for the Art of the Seventies* (New York: Praeger Publishers, 1972), 94.
12. Robert Smithson, "Letters," *Artforum* (September 1967): 4.
13. Robert Smithson, "Towards the Development of an Air Terminal Site," *Artforum* (Summer 1967): 38, 40.
14. See John Chandler and Lucy R. Lippard, "The Dematerialization of Art," *Art International* (February 1968).
15. Sol LeWitt, "Paragraphs on Conceptual Art," *Artforum* (Summer 1967): 80, 83.
16. Barbara Rose and Irving Sandler, eds., "Sensibility of the Sixties," *Art in America* (January/February 1967): 44–57.
17. Irving Sandler, "Introduction," *Critics Choice 1969–70,* exhibition catalogue (New York: New York State Council on the Arts and State University of New York, 1969): n.p.

Catalogue of the Exhibition

Unless otherwise noted, all works were begun and/or completed in 1967. All dimensions are in inches, and height precedes width precedes depth.

CARL ANDRE
Born Quincy, Massachusetts, 1935

64 Steel Square
Hot-rolled steel
64-unit square (8 x 8)
⅜ x 8 x 8 each
⅜ x 64 x 64 overall
Courtesy Paula Cooper Gallery, New York

MEL BOCHNER
Born Pittsburgh, Pennsylvania, 1940

Diagonals Constant
Colored pencil and ink on paper
18¼ x 24
Collection Mr. and Mrs. Victor W. Ganz, New York

ALEXANDER CALDER
Born Philadelphia, Pennsylvania, 1898; died 1976

La Grande Vitesse
Maquette, 1968
Painted steel
18½ x 24 x 10½
Collection National Endowment for the Arts, Washington, D.C.

Valentine, 1970
Gouache on paper
23¼ x 31
Collection Mr. and Mrs. M. S. Keeler II, Grand Rapids, Michigan

CHRISTO
Born Gabrovo, Bulgaria, 1935

Whitney Museum of American Art, Wrapped, Project for New York
Fabric, twine, rope, polyethylene, wood, and paint
Scale model: 18¼ x 19⅛ x 21⅝
Lent by Jeanne-Claude Christo, New York

WALTER DE MARIA
Born Albany, California, 1935

Mind
Stainless steel
1 x 3⅞ x 24
Collection Heiner Friedrich, New York

DAN GRAHAM
Born Urbana, Illinois, 1942

Courtroom Steps
Black and white photograph
10¾ x 9¾
Collection Nicholas Logsdail, Lisson Gallery, London

"Ziggurat" Skyscraper, New York City
Black and white photograph
9¾ x 12¾
Collection the artist

Glass Office Building Window, Chicago
Black and white photograph
8¾ x 12¾
Collection the artist

Jewelry Shop Window, Chicago, Illinois
Color photograph
13½ x 10½
Collection Benjamin Buchloh, New York

5.

Hallway with Mirror of "Model Home,"
Staten Island, New York
Color photograph
11 x 14
Private collection

Bedroom in "Model Home," Staten
Island, New York
Color photograph
9¼ x 13¾
Collection the artist

*People in Highway Restaurant, Day
of Opening,* Jersey City, New Jersey
Color photograph
10¾ x 14
Collection Kasper Koenig, Cologne

*Family Groups in Front of Two New
Houses,* Staten Island, New York
Color photograph
11¼ x 15
Private collection

RED GROOMS
Born Nashville, Tennessee, 1937

620 North Michigan
Poster for "City of Chicago" exhibition
Hand-colored offset
28¾ x 22
Collection Lysiane Luong, New York

MICHAEL HEIZER
Born Berkeley, California, 1944

Model for *North, East, South, West*
(Painted plywood sunk into snow in
Sierra Nevada Mountains; not extant)
Nickel-plated tin and wood
12 x 60 x 12
Lent by the artist, courtesy Xavier
Fourcade, Inc., New York

AL HELD
Born Brooklyn, New York, 1928

Black, White, and Green
Charcoal and acrylic on canvas
100 x 87
Collection the artist

EVA HESSE
Born Hamburg, Germany, 1936;
died 1970

Washer Table
Sculpmetal over steel washers on
wood
36 x 36 x 1
Lent by Mr. and Mrs. Daniel W.
Dietrich II, Chester Springs,
Pennsylvania

Washer Table
Rubber washers on wood and metal
8½ x 49½ x 8½
(Base built by Sol LeWitt and given to
the artist, who then created washer
table)
Sol LeWitt Collection, courtesy
Wadsworth Atheneum, Hartford,
Connecticut

ROBERT INDIANA
Born New Castle, Indiana, 1928

*The Metamorphosis of Norma Jean
Mortenson*
Acrylic on canvas
102 x 102 (diamond)
Collection Robert L. B. Tobin,
San Antonio, Texas

RAY JOHNSON
Born Detroit, Michigan, 1927

Jan
Mixed media on paper
19¾ x 14½
Collection Jan and Ingeborg van der
Marck, Detroit, Michigan

DONALD JUDD
Born Excelsior Springs, Missouri,
1928

Untitled
Red lacquer on galvanized iron
5 x 40 x 8½
Collection PaineWebber Group Inc.,
New York

ON KAWARA
Born Aichi Prefecture, Japan, 1933

March 11, 1967
Acrylic on canvas
18 x 24
Collection the artist, courtesy Angela
Westwater, New York

ELLSWORTH KELLY
Born Newburgh, New York, 1923

Study for *White Over Blue,* exhibited
at Expo '67
Acrylic on newsprint
15½ x 11
Lent by the artist

JOSEPH KOSUTH
Born Toledo, Ohio, 1945

Meaning (Art as idea as idea)
Photostat on wood
48 x 48
Collection F. and D. Morellet, Cholet,
France

3

ALFRED LESLIE
Born Bronx, New York, 1927

Linda Cross
Oil on canvas
108 x 72
Collection the artist, courtesy Richard
Bellamy, New York

BARRY LE VA
Born Long Beach, California, 1941

*By Four/Equal Quantities (within
four equal spaces): Arranged;
Rearranged; Borrowed; Exchanged*
Aluminum rods, ball bearings, felt
Dimensions variable
Courtesy Sonnabend Gallery,
New York

SOL LEWITT
Born Hartford, Connecticut, 1928

123 6 Part
Balsa painted white on base
painted gray
Maquette: 12 5/16 x 43 7/8 x 4
Base: 1/2 x 51 7/8 x 11 7/8
Sol LeWitt Collection, courtesy
Wadsworth Atheneum, Hartford,
Connecticut

ROY LICHTENSTEIN
Born New York, New York, 1923

Modern Sculpture with Glass Wave
Brass, glass
91 x 26 x 27
Collection Ileana and Michael
Sonnabend, New York

AGNES MARTIN
Born Saskatchewan, Canada, 1912

Tundra
Acrylic on linen
72 x 72

Collection Mr. and Mrs. Daniel W.
Dietrich II, Chester Springs,
Pennsylvania

ROBERT MORRIS
Born Kansas City, Missouri, 1931

Untitled, 1967–70
Gray felt
66 (approx.) x 72 x 72
Collection Williams College Museum
of Art, Williamstown, Massachusetts
Gift of Leo Castelli

BRUCE NAUMAN
Born Fort Wayne, Indiana, 1941

Series of 11 color photographs,
1966–68
Bound to Fail
19 13/16 x 23 7/16
*Coffee Spilled Because the Cup Was
Too Hot*
19 7/16 x 23 1/4
*Coffee Thrown Away Because It Was
Too Cold*
19 7/8 x 23 9/16
Drill Team
19 3/4 x 22 7/8
Eating My Words
19 15/16 x 23
Finger Touch #1
19 13/16 x 23 7/16
Finger Touch with Mirrors
19 11/16 x 23 1/2
Feet of Clay
19 3/8 x 23 1/16
Self-Portrait as a Fountain
19 5/8 x 23 5/8
Untitled
19 15/16 x 23 5/8

Waxing Hot
19 3/4 x 20
Courtesy Holly Solomon Gallery,
New York

BARNETT NEWMAN
Born New York, New York, 1905;
died 1970

Drawing for *Broken Obelisk*
Ink on paper
12 1/2 x 9 1/4
Collection Menil Foundation,
Houston, Texas

CLAES OLDENBURG
Born Stockholm, Sweden, 1929

Giant Fagends
Canvas, urethane foam, wood
52 x 96 x 96
Collection Whitney Museum of American Art, New York; purchase, with
funds from the Friends of the Whitney
Museum of American Art

JULES OLITSKI
Born New York, New York, 1922

Galliloo
Acrylic on canvas
93 1/2 x 43
Collection the artist, courtesy Andre
Emmerich Gallery, New York

DENNIS OPPENHEIM
Born Mason City, Washington, 1938

Viewing Station #1
Birch plywood model
12 x 15 x 15
Collection the artist

Octangular Viewing Station #2
Birch plywood model
10 x 28 x 22
Collection the artist

ROBERT RAUSCHENBERG
Born Port Arthur, Texas, 1925

Revolver
Mixed media
78 x 77 x 24½
Lent by the artist

ED RUSCHA
Born Omaha, Nebraska, 1937

Royal Road Test
Collaboration with Mason Williams
and Patrick Blackwell
62 page spiral-bound book
9½ x 6½
Collection Archives of the Institute
of Contemporary Art, University of
Pennsylvania, Philadelphia

*Thirty-Four Parking Lots in Los
Angeles*
44 page perfect-bound book
10 x 8
Collection Archives of the Institute
of Contemporary Art, University of
Pennsylvania, Philadelphia

LUCAS SAMARAS
Born Kastoria, Macedonia, Greece,
1936

Plan for Room #3
Pencil on paper
14 x 16¼
Courtesy The Pace Gallery, New York

Box #62
Mixed media
6¾ x 12⅜ x 9¼
Collection Mrs. Edwin Bergman,
Chicago, Illinois

RICHARD SERRA
Born San Francisco, California, 1939

Chunk
Vulcanized rubber
52 x 2 x 4
Collection Barbara and Peter Moore,
New York

TONY SMITH
Born Orange, New Jersey, 1912;
died 1979

Smoke
Cast bronze
24 x 48 x 31
Estate of the artist, courtesy Xavier
Fourcade, Inc., New York

ROBERT SMITHSON
Born Passaic, New Jersey, 1938;
died 1973

Gyrostasis, 1967–68
White painted steel
41½ x 24 x 30
Collection Virginia Dwan, New York

*Wandering Earth Mounds and Gravel
Paths*
Graphite and letraset on paper
10¾ x 14
Estate of the artist, courtesy John
Weber Gallery, New York

*Project for "Clear Zone," Dallas–
Fort Worth Regional Airport*
Pencil on graph paper
11 x 8½
Estate of the artist, courtesy John
Weber Gallery, New York

FRANK STELLA
Born Malden, Massachusetts, 1936

Abra, 1969
Fluorescent acrylic on canvas
120 x 120
Collection University of Pennsylvania,
Philadelphia, donated by Fanne Pela-
vin in honor of Howard Mack family

RICHARD TUTTLE
Born Rahway, New Jersey, 1941

Untitled
Dyed cloth
38 x 40½
Collection the artist, courtesy Blum
Helman Gallery, New York

ANDY WARHOL
Born Forest City, Pennsylvania, 1931;
died 1987

Sidney Janis
Photosensitive gelatin and tinted
lacquer on silkscreen on wood frame
95½ x 76⅛
Collection The Museum of Modern
Art, New York, The Sidney and Harriet
Janis Collection (fractional gift), 1967

Related Materials

BETSEY JOHNSON
Born Weathersfield, Connecticut,
1942

Tie-back dress
Rayon-cotton jersey
Collection the designer

BRIAN O'DOHERTY
Born Ballaghaderrin, Ireland, 1934

Guest editor-designer *Aspen Maga-
zine,* no. 5 and 6 combined, Fall-
Winter 1967

Works in the
Exhibition

All dimensions are in inches. All works are
dated 1967, unless otherwise indicated.

CARL ANDRE
64 Steel Square
Hot-rolled steel
64-unit square (8 x 8)
⅜ x 8 x 8 each
⅜ x 64 x 64 overall
Courtesy Paula Cooper Gallery,
New York

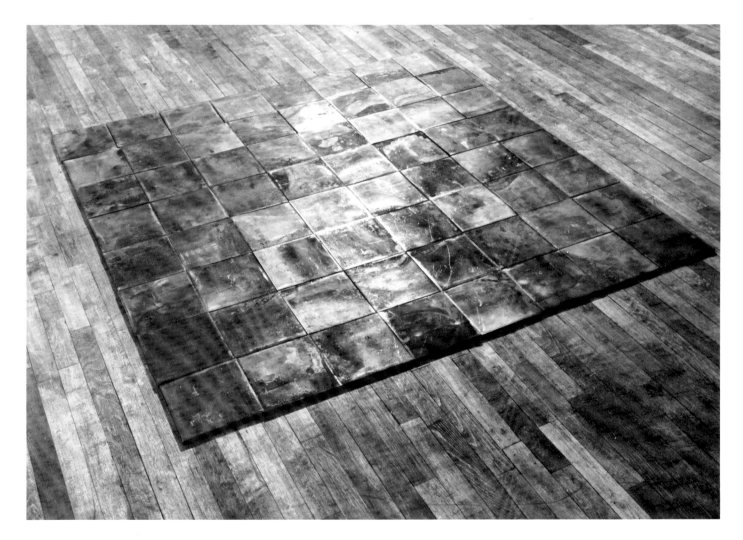

MEL BOCHNER
Diagonals Constant
Colored pencil and ink on paper
18¼ x 24
Collection Mr. and Mrs. Victor W. Ganz,
New York

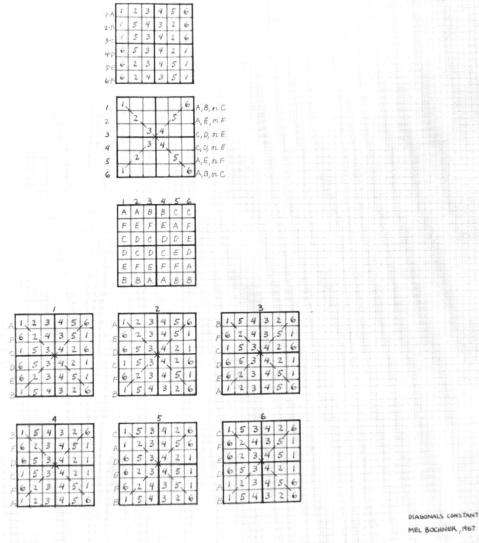

ALEXANDER CALDER
La Grande Vitesse, Maquette, 1968
Painted steel
18½ x 24 x 10½
Collection National Endowment for the Arts,
Washington, D.C.

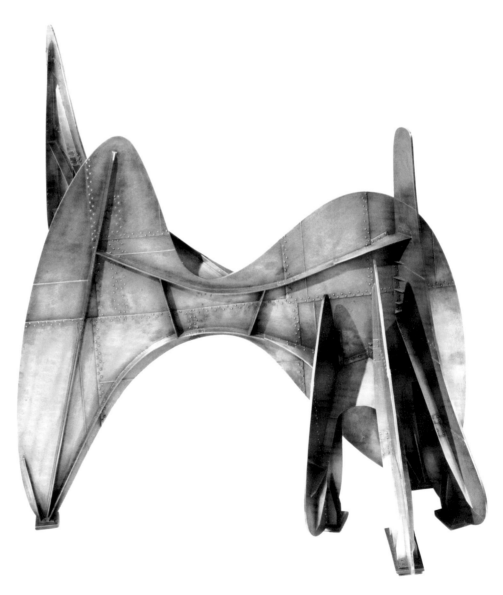

CHRISTO
Whitney Museum of American Art,
Wrapped, Project for New York
Fabric, twine, rope, polyethylene,
wood, and paint
Scale model: 18¼ x 19⅛ x 21⅝
Lent by Jeanne-Claude Christo, New York
Photograph copyright © by Christo

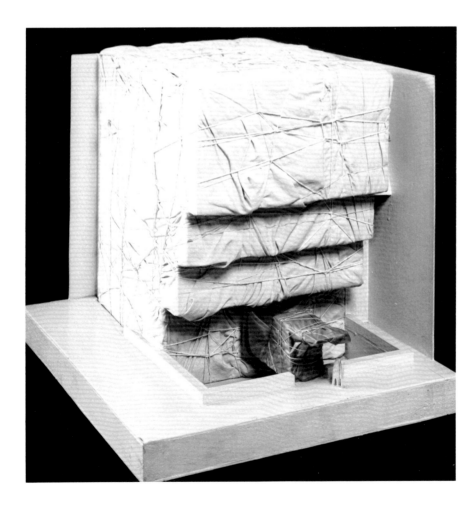

WALTER DE MARIA
Mind
Stainless steel
1 x 3⅞ x 24
Collection Heiner Friedrich, New York

DAN GRAHAM

[1]*Courtroom Steps*
Black and white photograph
10¾ x 9¾
Collection Nicholas Logsdail,
Lisson Gallery, London

[2]*Jewelry Shop Window,* Chicago, Illinois
Color photograph
13½ x 10½
Collection Benjamin Buchloh,
New York

[3]*Family Groups in Front of
Two New Houses,* Staten Island, New York
Color photograph
11¼ x 15
Private collection

[4]*Homes for America*
Arts Magazine,
December 1966–January 1967
(not in exhibition)

1

2

3

4

RED GROOMS

In collaboration with Mimi Gross
City of Chicago
Collection The Art Institute of Chicago
(not in exhibition)

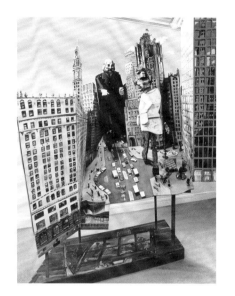

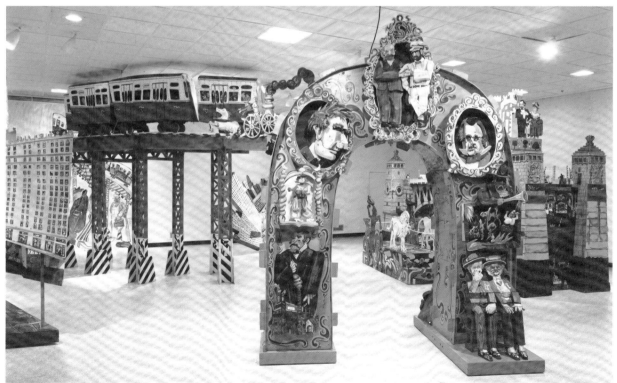

MICHAEL HEIZER
[1]Model for *North, East, South, West*
Nickel-plated tin and wood
12 x 60 x 12
Lent by the artist
Courtesy Xavier Fourcade, Inc., New York

[2]*South* (site photograph), Sierra Nevada, California
Painted plywood sunk into snow
in Sierra Nevada Mountains; not extant
48 diameter x 48 deep

[3]*North* (site photograph), Sierra Nevada, California
Painted plywood sunk into snow
in Sierra Nevada Mountains; not extant
48 x 48 x 48

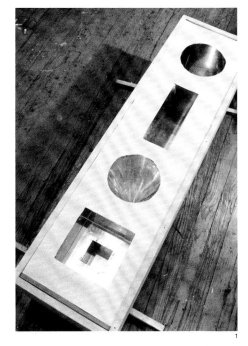

1

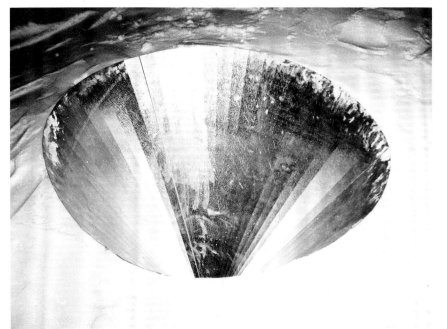

2

3

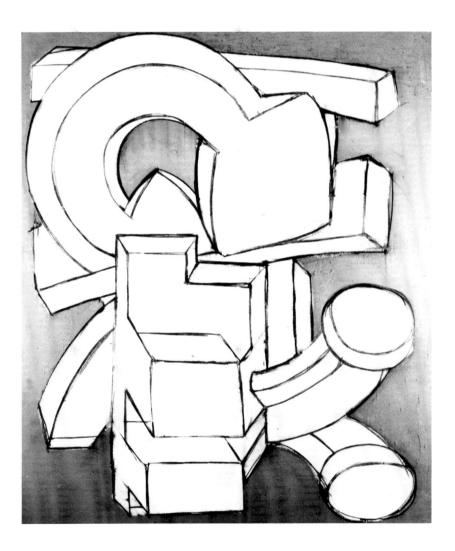

AL HELD
Black, White, and Green
Charcoal and acrylic on canvas
100 x 87
Collection the artist

EVA HESSE
Washer Table
Rubber washers on wood and metal
8½ x 49½ x 8½
Sol LeWitt Collection
Courtesy Wadsworth Atheneum, Hartford, Connecticut

ROBERT INDIANA
The Metamorphosis of Norma Jean Mortenson
Acrylic on canvas
102 x 102 (diamond)
Collection Robert L. B. Tobin,
San Antonio, Texas

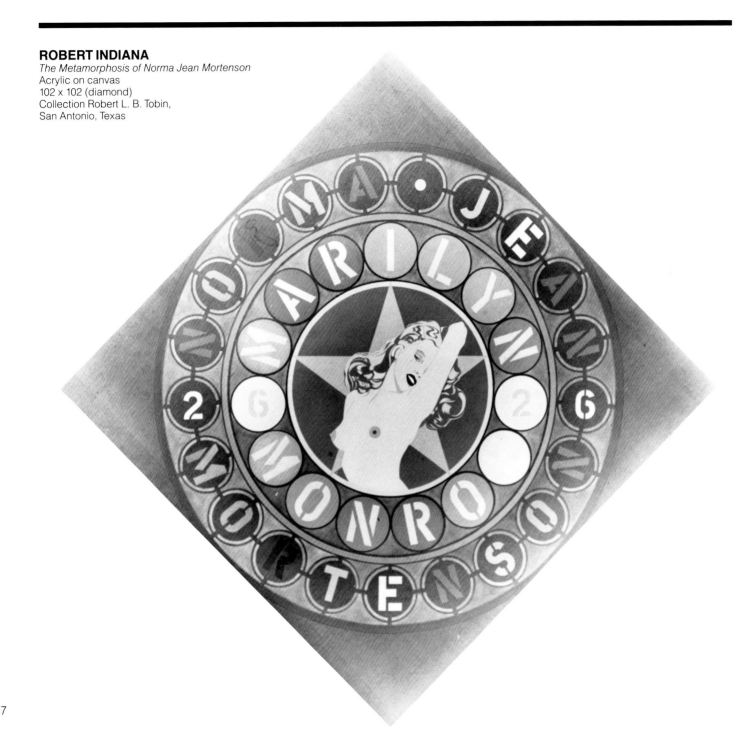

RAY JOHNSON
Jan
Mixed media on paper
19¾ x 14½
Collection Jan and Ingeborg van der Marck,
Detroit, Michigan

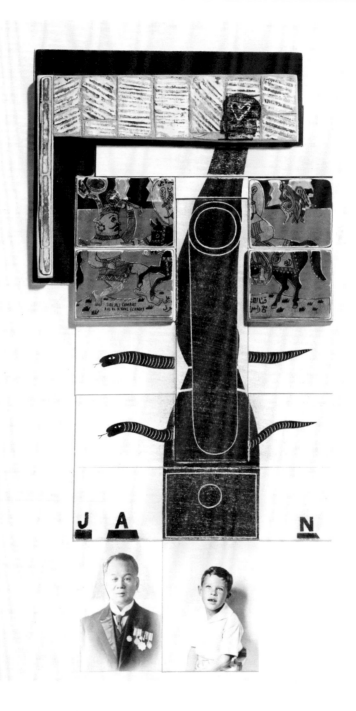

68

DONALD JUDD
Untitled
Red lacquer on galvanized iron
5 x 40 x 8½
Collection PaineWebber Group Inc.,
New York

69

ON KAWARA
March 11, 1967
Acrylic on canvas
18 x 24
Collection the artist
Courtesy Angela Westwater, New York

ELLSWORTH KELLY
[1]Study for *White Over Blue*
Acrylic on newsprint
15½ x 11
Lent by the artist

[2]*White Over Blue*
(site photograph), Expo '67
Montreal, Canada

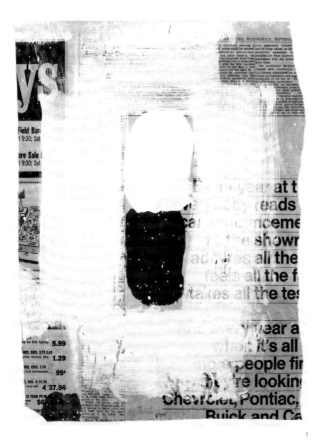

71

JOSEPH KOSUTH
Meaning (Art as idea as idea)
Photostat on wood
48 x 48
Collection F. and D. Morellet,
Cholet, France

7

ALFRED LESLIE
Linda Cross
Oil on canvas
108 x 72
Collection the artist
Courtesy Richard Bellamy, New York

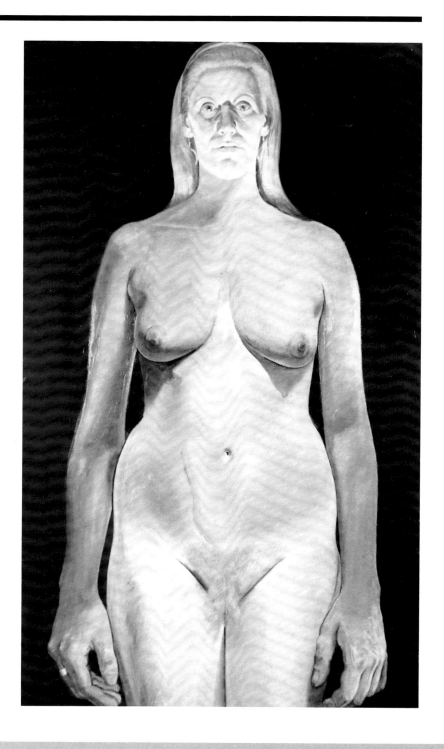

BARRY LE VA
By Four/Equal Quantities (within four equal spaces):
Arranged; Rearranged; Borrowed; Exchanged
Aluminum rods, ball bearings, felt
Dimensions variable
Courtesy Sonnabend Gallery, New York

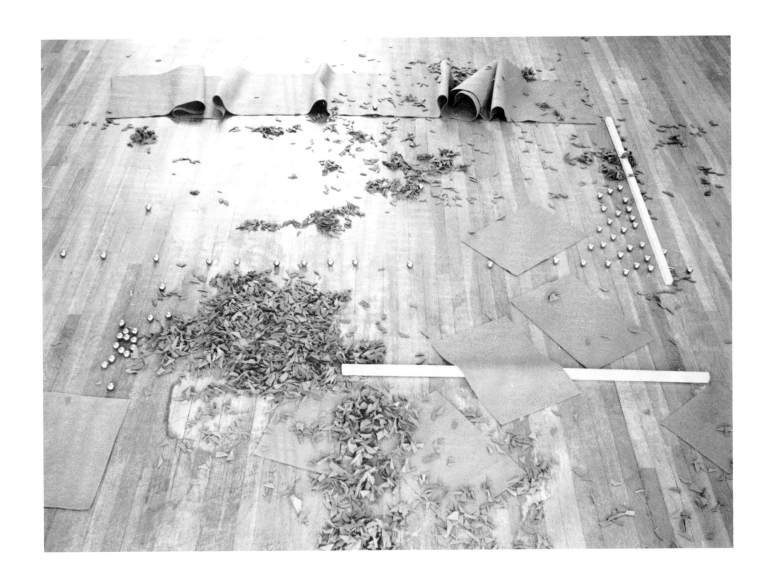

SOL LEWITT
7 Part Variations of 2 Different
Cubes (2–3)
White painted plastic and wood
9 x 23 x 23
(not in exhibition)

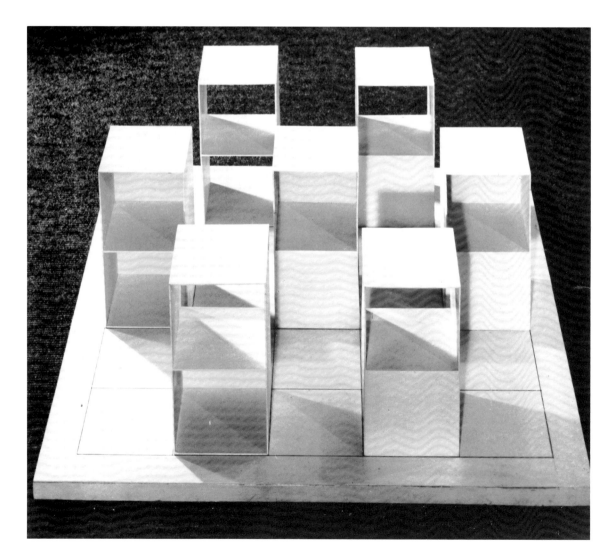

ROY LICHTENSTEIN
Modern Sculpture with Glass Wave
Brass, glass
91 x 26 x 27
Collection Ileana and Michael Sonnabend,
New York

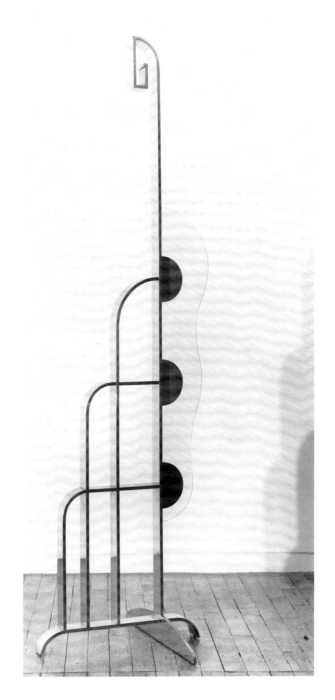

76

AGNES MARTIN
Tundra
Acrylic on linen
72 x 72
Collection Mr. and Mrs. Daniel W. Dietrich II,
Chester Springs, Pennsylvania

ROBERT MORRIS
Untitled, 1967–70
Gray felt
66 (approx.) x 72 x 72
Collection Williams College Museum of Art,
Williamstown, Massachusetts, gift of Leo Castelli

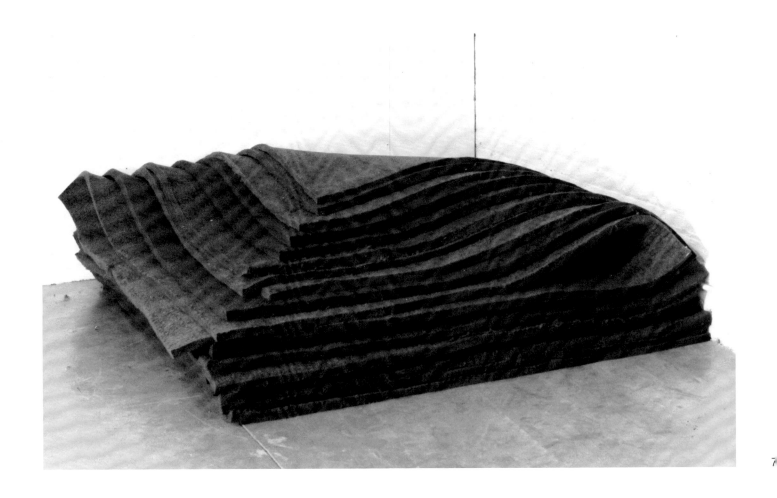

BRUCE NAUMAN

[1]*Waxing Hot*
Color photograph
19¾ x 20
Courtesy Holly Solomon Gallery, New York

[2]*Self-Portrait as a Fountain*
Color photograph
19⅝ x 23⅝
Courtesy Holly Solomon Gallery, New York

[3]*Bound to Fail*
Color photograph
19¹³⁄₁₆ x 23⁷⁄₁₆
Courtesy Holly Solomon Gallery, New York

[4]*Eating My Words*
Color photograph
19¹⁵⁄₁₆ x 23
Courtesy Holly Solomon Gallery, New York

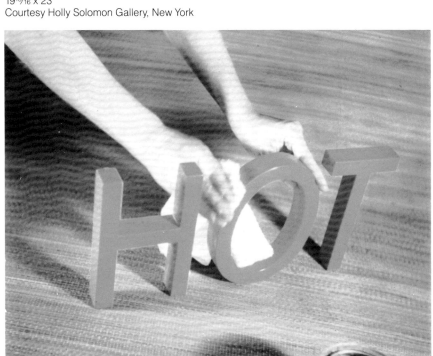

2

1

3

4

BARNETT NEWMAN
Broken Obelisk
(site photograph)
Corcoran Gallery of Art, Washington, D.C.

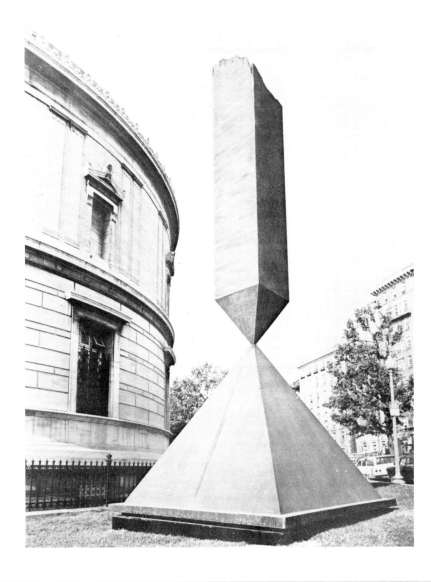

CLAES OLDENBURG
Giant Fagends
Canvas, urethane foam, wood
52 x 96 x 96
Collection Whitney Museum of American Art,
New York; installation view, "Proposals
for Monuments," Sidney Janis Gallery, May

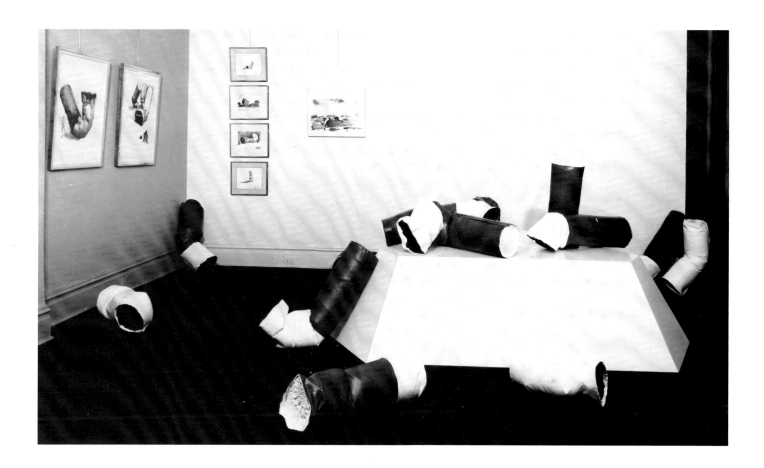

81

JULES OLITSKI
Galliloo
Acrylic on canvas
93½ x 43
Collection the artist
Courtesy Andre Emmerich Gallery, New York

DENNIS OPPENHEIM

[1]*Octangular Viewing Station #2*
Pencil on vellum
24 x 36
Not extant (not in exhibition)

[2]*Octangular Viewing Station #2*
Proposal for San Francisco Museum of Art
Birch plywood model
10 x 28 x 22
Collection the artist

1

83

2

ROBERT RAUSCHENBERG
"Revolvers" (installation view)
Leo Castelli Gallery, New York, May

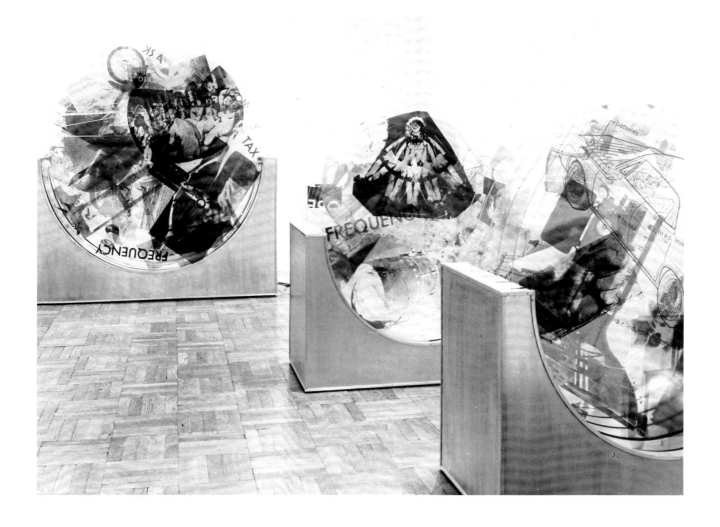

ED RUSCHA
Pages from *Thirty-Four Parking Lots
in Los Angeles*
44 page perfect-bound book
10 x 8
Collection Archives of the
Institute of Contemporary Art,
University of Pennsylvania, Philadelphia

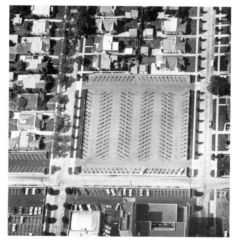
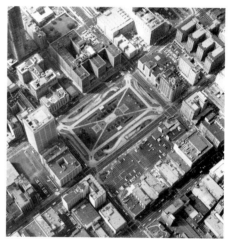

LUCAS SAMARAS

[1]*Plan for Room #3*
Pencil on paper
14 x 16¼
Courtesy The Pace Gallery, New York

[2]*Room #3* (installation view)
Mirror on wood frame
108 x 108 x 108
Saatchi Collection, London
(not in exhibition)

1

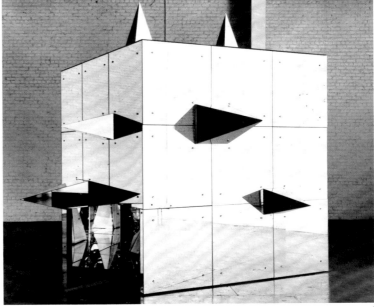

2

RICHARD SERRA
Chunk
Vulcanized rubber
52 x 2 x 4
Collection Barbara and Peter Moore,
New York
Photograph © copyright by Peter Moore

TONY SMITH
Smoke
Cast bronze
24 x 48 x 31
Estate of the artist
Courtesy Xavier Fourcade, Inc.,
New York

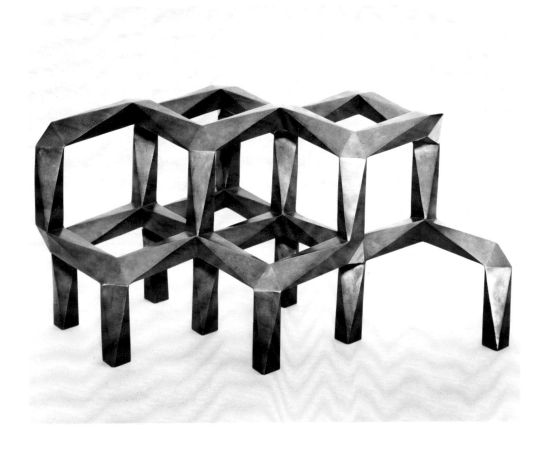

ROBERT SMITHSON
[1]*Gyrostasis,* 1967–68
White painted steel
41½ x 24 x 30
Collection Virginia Dwan, New York

[2]*Gyrostasis* (installation view)
Virginia Dwan Gallery, New York

1

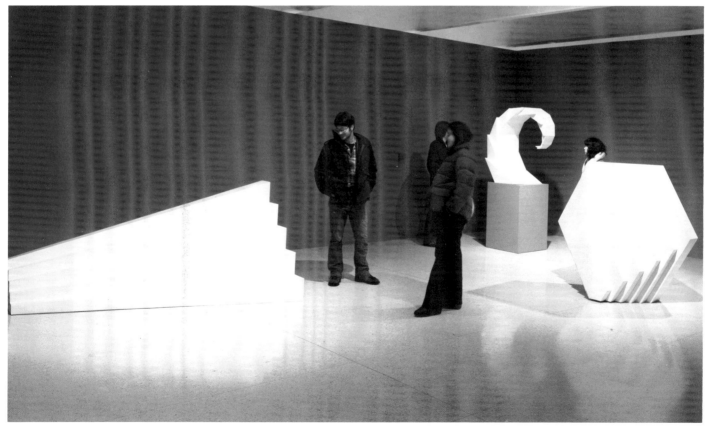

9

2

FRANK STELLA
Abra, 1969
Fluorescent acrylic on canvas
120 x 120
Collection University of Pennsylvania,
Philadelphia, donated by Fanne Pelavin
in honor of Howard Mack family

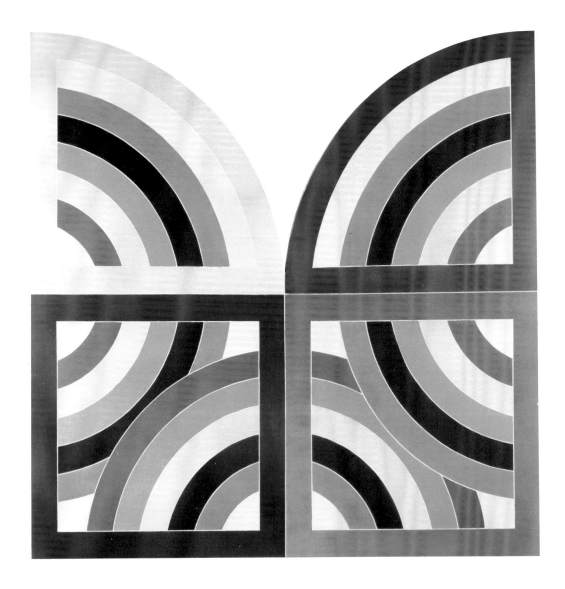

RICHARD TUTTLE
Untitled
Dyed cloth
38 x 40½
Collection the artist
Courtesy Blum Helman Gallery, New York

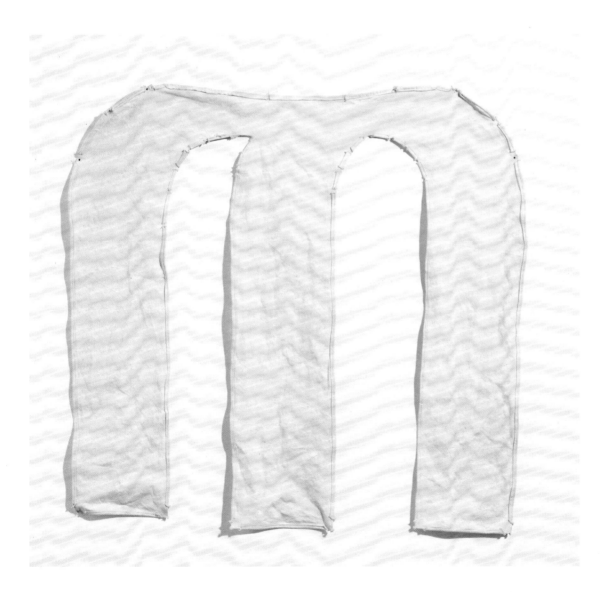

ANDY WARHOL
Sidney Janis
Photosensitive gelatin and tinted lacquer
on silkscreen on wood frame
95½ x 76⅛
Collection The Museum of Modern Art,
New York, The Sidney and Harriet
Janis Collection (fractional gift)

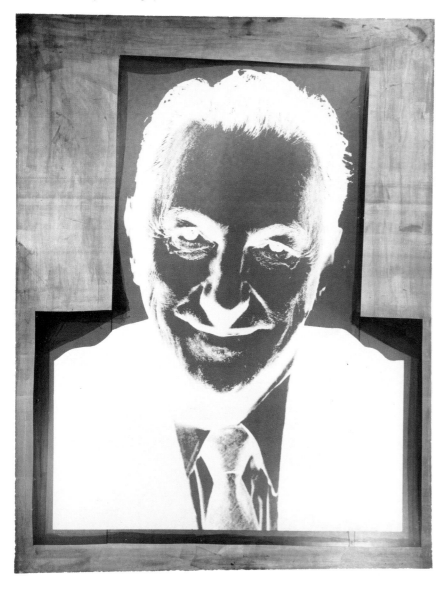

92

BETSEY JOHNSON
Tie-back dress
Rayon-cotton jersey
Collection the designer

BRIAN O'DOHERTY
Guest editor-designer
Aspen Magazine, no. 5 and 6 combined,
Fall-Winter 1967

Art Activities 1967

Janet Kardon

Carl Andre installs 1,232 gray concrete bricks on floor of Virginia Dwan Gallery, leaving areas without bricks to form eight nonuniform rectangular islands.

William Anastasi shows paintings of the walls on which his paintings hang (reduced by 10 percent) at Virginia Dwan Gallery, April–May.

Richard Anuszkiewicz shows at Sidney Janis Gallery, October.

Billy Apple shows UFOs (Unidentified Fluorescent Objects) at Howard Wise Gallery, November.

Willem de Kooning's oils are priced from $12,000 to $55,000 in his first one-person New York show in five years, at Knoedler and Co.

Dan Flavin installs fluorescent corner and wall pieces at Jill Kornblee Gallery, January.

Red Grooms completes first sculpto-pictorama, *Chicago;* shown at Allen Frumkin Gallery, Chicago, January 1968.

Michael Heizer creates one of his first earthworks, *North, East, South, West.* (Inverted geometric forms are lined up with painted plywood sunk into the ground in the Sierra Nevada Mountains.)

Al Held's *Greek Garden,* first displayed in his studio, is called the "largest abstract painting."

Peter Hutchinson shows at Sachs Gallery, November.

Roy Lichtenstein and Allan Kaprow have retrospectives at Pasadena Art Museum.

Rockne Krebs shows at Byron Gallery, October.

Robert Motherwell's *Open* series provokes much discussion. He has retrospective at The Museum of Modern Art.

Louise Nevelson has retrospective at Whitney Museum of American Art, 8 March–30 April.

Kenneth Noland shows horizontal, striped canvases at Andre Emmerich Gallery.

STEPHEN ANTONAKOS, *Orange Vertical Floor Neon,* programmed neon and metal, 108 x 72 x 72, collection Wadsworth Atheneum, Hartford, Connecticut. Copyright © by Stephen Antonakos.

KENNETH NOLAND, *Western Set,* acrylic on canvas, 18 x 82, courtesy Andre Emmerich Gallery, New York.

9

"Light, Motion, Space," installation view, Walker Art Center, Minneapolis, Minnesota.

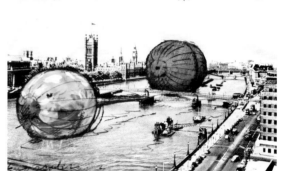

CLAES OLDENBURG, *Proposed Colossal Monument for Thames River: Thames Ball,* crayon, pen, and watercolor on postcard, 3½ x 5½, collection Carroll Janis.

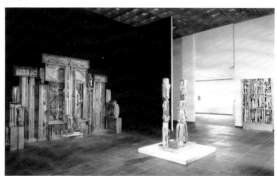

LOUISE NEVELSON exhibition, installation view, Whitney Museum of American Art, 8 March–20 April.

Claes Oldenburg shows his "Proposals for Monuments" at Sidney Janis Gallery.

Dennis Oppenheim shows "Roles of Painting" at Comara Gallery, Los Angeles; exhibition advertisement features large roll of "Noland" stripes.

The Museum of Modern Art presents first retrospective of Pablo Picasso's sculpture.

Jackson Pollock retrospective at The Museum of Modern Art. William Rubin's *Artforum* series of articles on Pollock inspires exchange of letters with Harold Rosenberg.

Jewish Museum opens Ad Reinhardt retrospective, December.

Ed Ruda and Dean Fleming have shows at Park Place Gallery.

Whitney Museum of American Art presents Raphael Soyer retrospective.

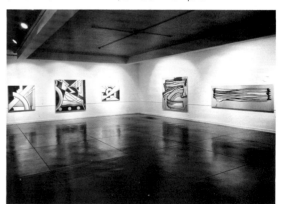

ROY LICHTENSTEIN exhibition, installation view, Pasadena Art Museum, Pasadena, California, 17 April–28 May.

The Graduate

Bonnie and Clyde

The Dirty Dozen

Kenneth Snelson shows at Virginia Dwan Gallery, January.

Frank Stella shows at Leo Castelli Gallery, December.

Takis shows at Howard Wise Gallery, April.

Paul Thek shows at Stable Gallery, October.

Neil Welliver shows at Tibor de Nagy Gallery, 18 November–7 December.

John Willenbecher shows at Feigen Gallery, Chicago, September–October.

Robert Whitman shows at Pace Gallery, October.

Andrew Wyeth exhibition, organized by Pennsylvania Academy of the Fine Arts, attracts waiting lines around the block when it travels to Whitney Museum of American Art, 6 February–12 April.

Jack Youngerman shows at Betty Parsons Gallery, November.

ALEX HAY's *Grass Field,* in "Nine Evenings: Theater and Engineering," New York, 1966. Photograph copyright © by Peter Moore.

9

"Sculpture of the Sixties," plaza installation, Los Angeles County Museum of Art, 28 April–25 June.

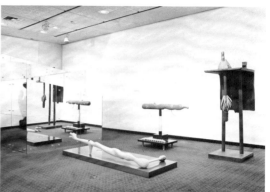

"Sculpture of the Sixties," installation view, Los Angeles County Museum of Art, 28 April–25 June.

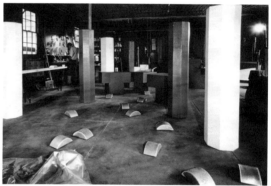

ROBERT BREER's studio in Palisades, New Jersey. Photograph copyright © by Peter Moore.

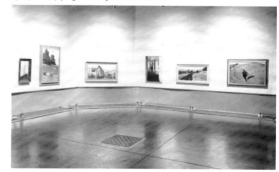

ANDREW WYETH exhibition, installation view, Pennsylvania Academy of the Fine Arts, Philadelphia, 1966.

Key group shows at New York galleries include "Homage to Marilyn Monroe," Sidney Janis Gallery; "Language to Be Looked at and/or Things to Be Read," Virginia Dwan Gallery; "Words," Feigen Gallery; "10 Years at Leo Castelli," Leo Castelli Gallery; and "Festival of Lights," Howard Wise Gallery.

Artists are discussing Wittgenstein, Bachelard, Borges, Bergson, Levi-Strauss, Robbe-Grillet's *Towards a New Novel,* Kubler's *The Shape of Time,* and filmmakers Antonioni and Godard.

"American Sculpture of the Sixties," Los Angeles County Museum of Art, organized by Maurice Tuchman, focuses upon declarative scale of recent sculpture.

"The Photographer's Eye," The Museum of Modern Art, organized by John Szarkowski.

The New School Art Center presents "Protest and Hope"; exhibition includes works on Vietnam War and civil rights issues.

"Art in Series" exhibition at Finch College Museum of Art, organized by Mel Bochner and Elayne Varian.

Germano Celant organizes first Arte Povera exhibition in Europe.

"Environment U.S.A.," São Paulo Bienal, organized by William Seitz, features twenty pop artists.

JOHN CAGE during performance of "Variations VII," in "Nine Evenings: Theater and Engineering," New York, 1966. Photograph copyright © by Peter Moore.

STEVE PAXTON, ROBERT RAUSCHENBERG, and large ensemble in "Urban Round." Photograph copyright © by Peter Moore.

"Sculpture of the Sixties," the Guggenheim International, organized by Edward Fry, is first international contemporary sculpture exhibition in U.S.

Ford Foundation grant enables five curators to survey country to select artists for Whitney Biennial. Sixty-four of 165 artists come from outside New York.

Brian O'Doherty is guest editor-designer of *Aspen* combined Fall-Winter 1967 issue. Includes text by Roland Barthes, Samuel Beckett, Dan Graham, George Kubler, Susan Sontag; recordings by William Burroughs, John Cage, Merce Cunningham, Marcel Duchamp, Morton Feldman, Max Neuhaus, Alain Robbe-Grillet; artworks by Mel Bochner, Sol LeWitt, O'Doherty, Tony Smith, among others.

"From 'Space to Environment,'" Matsuya Department Store, Tokyo, organized by Kankyo Group, features electronic movement and audience participation.

Robert Rauschenberg's *Booster* lithograph published by Gemini.

Andy Warhol's Marilyn Monroe silkscreen published by Factory Editions, New York.

Agnes Martin completes her last painting in New York, *Tundra,* and moves to New Mexico.

Michael Snow films *Wavelength.*

Yvonne Rainer presents first performance of *Convalescent Dance,* at Hunter College, New York, 2 February.

Simone Whitman review in February *Artforum* of "9 Evenings: Theater and Engineering," at New York 69 Regiment Armory, October 1966. Collaborative events coordinated by Billy Kluver include John Cage, Lucinda Childs, Oyvind Fahlstrom, Alex Hay, Deborah Hay, Steve Paxton, Yvonne Rainer, Robert Rauschenberg, David Tudor, and Robert Whitman.

Robert Smithson, as artist-consultant, develops plans for Dallas–Fort Worth Regional Airport.

Corcoran Gallery of Art is first museum to invite artists (Ronald Bladen, Barnett Newman, and Tony Smith) to create works expressly for its space, for "Scale as Content."

For "Sculpture in Environment" exhibition, Claes Oldenburg has grave behind Metropolitan Museum of Art excavated and then filled in by union workers.

Frank Stella begins his Protractor series.

Scott Burton criticizes Barbara Rose and Whitney Museum of Art for "omission of good recent figurative painting," in January *Artforum* letter.

Expo '67 is most successful world's fair in history. First attempt to bring visual unity to exposition grounds. R. Buckminster Fuller designs 250 x 200-foot geodesic dome, with 261 electric motors operating 4,700 metallic fabric shades that regulate temperature and change dome's color from silver to rainbow hues. "Sculpture '67" is major exhibition. Habitat is Israeli architect Moshe Safdie's pioneering apartment design. Soviet Pavilion has greatest attendance: 10,500,000.

Kenneth Noland does his earliest striped paintings.

Metropolitan Museum of Art presents "Is Fashion Art?"

Stephen Antonakos wins *Art in America* billboard contest, sponsored by Institute of Outdoor Advertising to encourage support of American museums.

Ad Reinhardt dies on 30 August, six months after his retrospective at Jewish Museum. His chronology appears in October *Artforum*.

Winners of 44th Pittsburgh International Exhibition are Josef Albers, Joan Miro, Eduardo Paolozzi, Francis Bacon, Arnaldo Pomodoro, and Victor Vasarely.

George Sugarman receives his first commission for an outdoor work, *From White to Yellow to White to Blue to Black,* for plaza in El Segundo, California.

National Endowment for the Arts funds pilot public-art project, Alexander Calder's *La Grande Vitesse,* in Grand Rapids, Michigan.

Charlotte Moorman arrested for indecent exposure during Nam June Paik performance of *Opera Sextronique.*

Time column, "Art in New York," lists exhibitions in museums and uptown and midtown galleries. Tony Smith featured on 13 October *Time* cover. Robert Rauschenberg painting reproduced on 8 December *Time* cover.

Robert Indiana designs sets, costumes, and poster for Center Opera Company's production of Virgil Thomson and Gertrude Stein's *The Mother of Us All,* at Tyrone Guthrie Theater, Minneapolis.

Thomas Hoving, director of Metropolitan Museum of Art, establishes department of contemporary art and appoints Henry Geldzahler chairman.

STEPHEN ANTONAKOS, billboard, a submission to the *Art in America* billboard contest.

CHARLOTTE MOORMAN performing Nam June Paik's *Opera Sextronique,* New York. Photograph copyright © by Peter Moore.

Selected Bibliography

Compiled by Jane Carroll

JAMES ROSENQUIST, "Study for Expo '67," oil on canvas, 74 x 38.

Monographs are not included in this bibliography.

ARTICLES AND BOOKS, 1967

Alloway, Lawrence. "Art as Likeness." *Arts Magazine* 41 (May 1967): 34–39.

———. "Hi-Way Culture: Man at the Wheel." *Arts Magazine* 41 (February 1967): 28–33.

Ashton, Dore. "Art as Spectacle." *Arts Magazine* 41 (March 1967): 44–46.

———. "Clothes Do But Cheat and Cousen Us." *Arts Magazine* 42 (December/January 1967–68): 40–42.

———. "The Distance from 1926 to 1966." *Arts Magazine* 41 (December/January 1966–67): 28–33.

Battcock, Gregory, ed. *The New American Cinema.* New York: E. P. Dutton, 1967.

"Billboards—Five Artists and an Industry." *Art in America* 55 (March–April 1967): 52–55.

Burnham, Jack. "Sculpture's Vanishing Base." *Artforum* (November 1967): 47–55.

———. "Systems Esthetics." *Artforum* (September 1968): 30–35.

Burton, Scott. "Letters." *Artforum,* (January 1967): 4.

Fried, Michael. "Art and Objecthood." *Artforum* (Summer 1967): 12–23.

Greenberg, Clement. "Problems of Criticism II: Complaints of an Art Critic." *Artforum* (October 1967): 38–39.

Johnston, Jill, Judith Dunn, Constance H. Poster, and others. Special issue on Judson Dance Theater. *Ballet Review* 1, no. 6 (1967).

Kozloff, Max. "The New American Painting: Post-Abstract-Expressionism—Mask and Reality," in Richard Kostelanetz, ed., *The New American Arts.* New York: Collier Books, 1967.

Laderman, Gabriel. "Unconventional Realists." *Artforum* (November 1967): 42–46.

Leider, Philip. "American Sculpture at the Los Angeles County Museum of Art." *Artforum* (Summer 1967): 6–11.

Lippard, Lucy R. "Homage to the Square." *Art in America* 55 (July/August 1967): 50–57.

Michelson, Annette. "10 x 10: 'concrete reasonableness.'" *Artforum* (January 1967): 30–31.

Monte, James. "'Making It' with Funk." *Artforum* (Summer 1967): 56–59.

"The New York Correspondence School." *Artforum* (October 1967): 50–55.

O'Doherty, Brian, ed. *Aspen Magazine,* no. 5 and 6 (Fall–Winter 1967).

Piene, Nan R. "Light Art." *Art in America* 55 (May/June 1967): 24–27.

Pincus-Witten, Robert. "Reviews: New York." *Artforum* (February 1967): 61.

———. "Sound, Light and Silence in Kansas City." *Artforum* (January 1967): 51–52.

100

Rose, Barbara. "Abstract Illusionism." *Artforum* (October 1967): 33–37.

————. "The Value of Didactic Art." *Artforum* (April 1967): 32–36.

Rose, Barbara, Michael Fried, Max Kozloff, and Sidney Tillim. *Art Criticism in the Sixties*. Waltham, Massachusetts: Poses Institute of Fine Arts, Brandeis University, 1967.

Rose, Barbara, and Irving Sandler. "Sensibility of the Sixties." *Art in America* 55 (January/February 1967): 44–57.

Rubin, William. "Jackson Pollock and the Modern Tradition." *Artforum* (May 1967): 28–33.

Selz, Peter. "West Coast Report: Funk Art." *Art in America* 55 (March/April 1967): 92–93.

Solomon, Alan R. *New York: The New Art Scene*. Photographs by Ugo Mulas. New York: Holt, Rinehart and Winston, 1967.

Tillim, Sidney. "Scale and the Future of Modernism." *Artforum* (October 1967): 14–18.

ARTISTS' WRITINGS, 1967

Artschwager, Richard. "The Hydraulic Door Check." *Arts Magazine* 42 (November 1967): 41–43.

Bannard, Darby. "Present-Day Art and Ready-Made Styles in Which the Formal Contribution of Pop Art Is Found to Be Negligible." *Artforum* (December 1966): 3–35.

Bochner, Mel. "The Beach Boys— '100%'" *Arts Magazine* 41 (March 1967): 24.

————. "Serial Art Systems: Solipsism." *Arts Magazine* 41 (Summer 1967): 39–43.

————. "The Serial Attitude." *Artforum* (December 1967): 28–33.

Davis, Douglas M. "The Dimensions of the Miniarts." *Art in America* 55 (November 1967): 84–91.

Flavin, Dan. "Some other comments" *Artforum* (December 1967): 20–25.

Graham, Dan. "The Book as Object." *Arts Magazine* 41 (Summer 1967): 23.

————. "Carl Andre." *Arts Magazine* 42 (December/January 1967–68): 34–35.

————. "Homes for America." *Arts Magazine* 41 (December/January 1966–67): 21–22.

————. "Models & Monuments." *Arts Magazine* 41 (March 1967): 32–35.

————. "Muybridge Moments: From Here to There?" *Arts Magazine* 41 (February 1967): 23–24.

Hutchinson, Peter. "The Critics' Art of Labeling." *Arts Magazine* 41 (May 1967): 19–20.

————. "The Fictionalization of the Past." *Arts Magazine* 42 (December/January 1967–68): 31–33.

Kaprow, Allan. "Death in the Museum." *Arts Magazine* 41 (February 1967): 40–41.

LeWitt, Sol. "Paragraphs on Conceptual Art." *Artforum* (Summer 1967): 79–83.

Michals, Duane. "The Empty Environment." *Art in America* 55 (July/August 1967): 104–9.

Morris, Robert. "A Method for Sorting Cows." *Art and Literature,* vol. 11 (Winter 1967): 180.

————. "Notes on Sculpture." *Artforum* (February 1966): 42–44.

————. "Notes on Sculpture, Part 2." *Artforum* (October 1966): 20–23.

————. "Notes on Sculpture, Part 3: Notes and Nonsequiturs." *Artforum* (Summer 1967): 24–29.

————. "Notes on Sculpture, Part 4: Beyond Objects." *Artforum* (April 1969): 50–54.

Oldenburg, Claes. "Take a Cigarette Butt and Make It Heroic." *Artnews* 66 (May 1967): 30–31.

Piene, Otto. "Theater Architecture." *Arts Magazine* 42 (September/October 1967): 20–22.

Plagens, Peter. "Present-Day Styles and Ready-Made Criticism in Which the Formal Contribution of Pop Art Is Found to Be Minimal." *Artforum* (December 1966): 36–39.

Reinhardt, Ad. "Chronology." *Artforum* (October 1967): 46–47.

Ruda, Ed. "Park Place: 1963–1967." *Arts Magazine* 42 (November 1967): 30–33.

Samaras, Lucas. "Cornell Size." *Arts Magazine* 41 (May 1967): 45–47.

————. "An Exploratory Dissection of Seeing." *Artforum* (December 1967): 26–27.

Smithson, Robert. "The Monuments of Passaic." *Artforum* (December 1967): 48–51.

———. "Some Void Thoughts on Museums." *Arts Magazine* 41 (February 1967): 40–41.

———. "Towards the Development of an Air Terminal Site." *Artforum* (Summer 1967): 36–40.

———. "Ultramoderne." *Arts Magazine* 42 (September/October 1967): 30–33.

Whitman, Simone. "Theater and Engineering: An Experiment." *Artforum* (February 1967): 26–33.

GROUP EXHIBITION CATALOGUES, 1967

Alloway, Lawrence. *Systemic Painting*. New York: Solomon R. Guggenheim Museum, 1966.

Bellamy, Richard, Lucy R. Lippard, and Leah P. Sloshberg. *Focus on Light*. Trenton: New Jersey State Museum, 1967.

Carnegie Institute Museum of Art. *Pittsburgh International Exhibition of Contemporary Painting and Sculpture*. Pittsburgh: Carnegie Institute Museum of Art, 1967.

Green, Eleanor. *Scale as Content: Ronald Bladen, Barnett Newman, Tony Smith*. Washington, D.C.: Corcoran Gallery of Art, 1968.

Green; Samuel A. *Art for the City*. Philadelphia: Institute of Contemporary Art, 1967.

Solomon R. Guggenheim Museum. *Guggenheim International Exhibition 1967: Sculpture from 20 Nations*. New York: Solomon R. Guggenheim Museum, 1967.

Prokopoff, Stephen. *A Romantic Minimalism*. Philadelphia: Institute of Contemporary Art, 1967.

Rauh, Emily S. *7 for 67: Works by Contemporary American Sculptors*. St. Louis: City Art Museum of St. Louis, 1967.

Rose, Barbara. *A New Aesthetic*. Washington, D.C.: Washington Gallery of Modern Art, 1967.

Sharp, Willoughby. *Light, Motion, Space*. Minneapolis: Walker Art Center, 1967.

Tuchman, Maurice, ed. *American Sculpture of the Sixties*. Los Angeles: Los Angeles County Museum of Art, 1967.

van der Marck, Jan. *Pictures to Be Read, Poetry to Be Seen*. Chicago: Museum of Contemporary Art, 1967.

RELATED SOURCES

Alloway, Lawrence. *American Pop Art*. New York: Collier Books, in association with the Whitney Museum of American Art, 1974.

Amayo, Mario. *Pop Art . . . And After*. New York: Viking Press, 1966.

Armstrong, Richard, and Richard Marshall. *Entre la Geometria y el Gesto: Escultura Norteamericana, 1965–1975*. Madrid: Ministerio de Cultura, 1986.

Battcock, Gregory, ed. *Minimal Art: A Critical Anthology*. New York: E. P. Dutton, 1968.

Brown University, Department of Art. *Definitive Statements: American Art 1964–66*. Providence: Brown University, 1986.

Bunnell, Peter C. "Photographs for Collectors." *Art in America* 56 (January/February 1968): 70–75.

Campbell, Mary Schmidt. *Tradition and Conflict: Images of a Turbulent Decade, 1963–1973*. New York: The Studio Museum in Harlem, 1985.

Carmean, E. A., Jr. *The Great Decade of American Abstraction: Modernist Art 1960 to 1970*. Houston: Museum of Fine Arts, 1974.

Chandler, John, and Lucy R. Lippard. "The Dematerialization of Art." *Art International* (February 1968): 31–36.

Coe, Ralph T. *Sound, Light, Silence: Art That Performs*. Kansas City, Missouri: Nelson Gallery, Atkins Museum, 1966.

Davis, Douglas M. "Art and Technology—The New Combine." *Art in America* 56 (January/February 1968): 29–37.

Develing, Enno, and Lucy R. Lippard. *Minimal Art*. Netherlands: Gemeentemuseum, The Hague, 1968.

Finch College Museum of Art. *Art in Process: The Visual Development of a Structure*. New York: Finch College Museum of Art, 1966.

Friedman, Martin, and Jan van der Marck. *Eight Sculptors: The Ambiguous Image.* Minneapolis: Walker Art Center, 1966.

Granath, Olle (exhibition commissioner), Lucy R. Lippard, Ted Castle, and others. *Flyktpunkter—Vanishing Points.* Stockholm: Moderna Museet, 1984.

Haskell, Barbara. *Blam! The Explosion of Pop, Minimalism, and Performance 1958–1964.* New York: Whitney Museum of American Art, in association with W. W. Norton & Co., 1984.

Hunter, Sam. *Masters of the Sixties: From New Realism to Pop Art.* New York: Marisa Del Re Gallery, 1984.

Jenkins, Bruce, and Melinda Ward, eds. *The American New Wave, 1958–1967.* Minneapolis: Walker Art Center, 1982.

Kaprow, Allan. "The Happenings Are Dead." *Artforum* (March 1966): 36–39.

Kirby, Michael. *Happenings: An Illustrated Anthology.* New York: E. P. Dutton, 1966.

Kramer, Hilton. "Episodes from the Sixties." *Art in America* 58 (January/February 1979): 56–61.

Lippard, Lucy R. *Eccentric Abstraction.* New York: Fischbach Gallery, 1966.

———. *Pop Art.* With contributions by Lawrence Alloway, Nancy Marmer, Nicolas Calas. New York: Praeger, 1966.

———. "Rejective Art." *Art International* 10 (October 1966): 33–37.

———. *Six Years: The dematerialization of the art object from 1966 to 1973* New York: Praeger, 1973.

Martin, Marianne, Iris M. Fanger, Deborah Jowitt, David Vaughan, David A. Ross, and Elisabeth Sussman. *Art & Dance: Images of the Modern Dialogue, 1890–1980.* Boston: Institute of Contemporary Art, 1982.

McShine, Kynaston. *Primary Structures.* New York: Jewish Museum, 1966.

Miller-Keller, Andrea, and John B. Ravenal. *From the Collection of Sol LeWitt.* New York: Independent Curators Incorporated, 1984.

Necol, Jane, and Maurice Poirier, eds. "The '60s in Abstract: 13 Statements and an Essay." *Art in America* 71 (October 1983): 122–37.

Paoletti, John T., ed. *No Title: The Collection of Sol LeWitt.* Middletown, Connecticut: Wesleyan University, in association with the Wadsworth Atheneum, 1981.

Perron, Wendy, and Daniel J. Cameron, eds. *Judson Dance Theater: 1962–1966.* Bennington, Vermont: Bennington College Judson Project, Bennington College, 1981.

Pincus-Witten, Robert. *Postminimalism: American Art of the Decade.* New York: Out of London Press, 1977.

Project Studios One, Institute for Art and Urban Resources. *Abstract Painting: 1960–1969.* New York: Project Studios One, Institute for Art and Urban Resources, 1982.

Reise, Barbara, Dan Flavin, Carl Andre, and Donald Judd. Special issue on minimalism. *Studio International* 177 (April 1969).

Rose, Barbara. "ABC Art." *Art in America* 53 (October/November 1965): 57–69.

Selz, Peter, and George Rickey. *Directions in Kinetic Sculpture.* Berkeley: University of California, 1966.

Sitney, P. Adams. *Visionary Film: The American Avant-Garde.* New York: Oxford University Press, 1974.

ICA STAFF

Janet Kardon
Director

Judith E. Tannenbaum
Assistant Director

Carole S. Clarke
Chief Development Officer

Fran E. Kellenbenz
Business Administrator

Rosemarie Fabien
Public Relations/Marketing Officer

Thomas A. Bolze
Assistant to the Director

Jane Carroll
Curatorial Assistant

Victoria L. Glickstein
Curatorial Assistant

Christine Watt
Membership Secretary

John Taylor
Chief Preparator

William Baumann
Randall Dalton
Max Mason
Ron Rozewski
Gregory Tobias
Jack Toland
Preparators

ICA ADVISORY BOARD

Susan D. Ravenscroft, *Chairman*
Dr. Milton Brutten
Stephen B. Burbank
Lee G. Copeland
Thomas Neil Crater
Elaine Dannheisser
Daniel W. Dietrich II
Dr. Claire M. Fagin
Mrs. Jack M. Friedland
Robert Goodman
Mrs. Robert A. Hauslohner
Mrs. L. Harvey Hewit
Mrs. Harold A. Honickman
Diane Karp
Mrs. Berton E. Korman
Herbert W. Leonard
Judith T. Lieb
Marvin Lundy
Mrs. A. Bruce Mainwaring
Mrs. William E. McKenna
Henry S. McNeil, Jr.
Donald W. McPhail
Allen J. Model
Suzanne Morgan
Mrs. Ramon Naus
Mrs. Karl F. Rugart, Jr.
Mrs. Robert Saligman
Ella B. Schaap
Susan C. Stafford
Walter E. Stait
Marilyn L. Steinbright
Benjamin Strauss
Peter L. Svanda
Edna S. Tuttleman

PHOTOGRAPHY CREDITS

Jon Abbott: 76; AP/Wide World Photos: 11, 27; Ferdinand Boesch: 86 (1); Rudolph Burckhardt: 15, 84, 100; Geoffrey Clements: 12 (top), 81, 95 (center right); Columbia Pictures Industries, Inc. copyright © 1970: 96 (center left); Bevan Davies: 72; eeva-inkeri: 60; Embassy Pictures Corp. copyright © 1967: 96 (top left); Betsey Johnson: 68; Bruce C. Jones: 88; Eric Mitchell: 77; Eugene Mopsik: 93 (right); The Pace Gallery: 86 (right); Eric Pollitzer: 73, 78; Earl Ripling: 91; Robinson Studio: 59; Walter Russell: 28, 29; Warren Silverman: 83 (1); Eric Sutherland: 95 (top left); Joseph Szaszfai: 66; Frank J. Thomas: 61, 95 (bottom right); Jerry L. Thompson: 71 (1); John Weber Gallery: 18, 19, 37; Dorothy Zeidman: 69, 70.

Photographs reproduced in this catalogue have been provided, in the majority of cases, by the owners or custodians of the works indicated in the captions. Individual works of art or images appearing here may be additionally protected by copyright in the United States or abroad, and may not be reproduced in any form without the permission of the copyright owners.